lighting | for portrait
photography

Steve Bavister

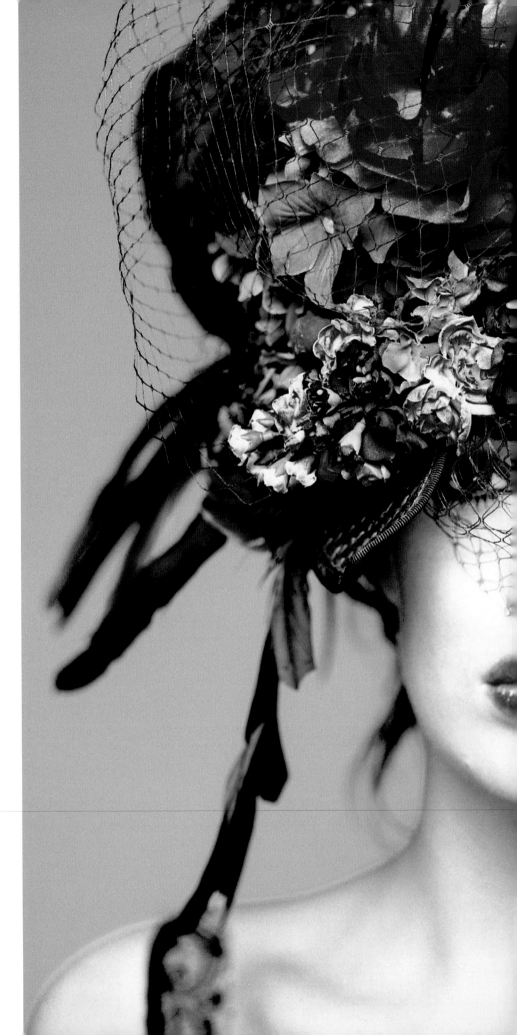

RotoVision

A RotoVision Book
Published and distributed by
RotoVision SA, Route Suisse 9
CH-1295 Mies
Switzerland

RotoVision SA, Sales & Editorial Office
Sheridan House, 114 Western Road
Hove, East Sussex BN3 1DD, UK

Tel: +44 (0)1273 72 72 68
Fax: +44 (0)1273 72 72 69
E-mail: sales@rotovision.com
Web: www.rotovision.com

ISBN 978-2-940378-30-2

10 9 8 7 6 5 4

Art director Tony Seddon

Original book design by Red Design

Revised edition 2007 by Steve Luck

Illustrations by Rob Brandt

Reprographics in Singapore by ProVision Pte. Ltd.

Tel: +65 6334 7720
Fax: +65 6334 7721

Printing and binding in Singapore by
Craft Print International Ltd.

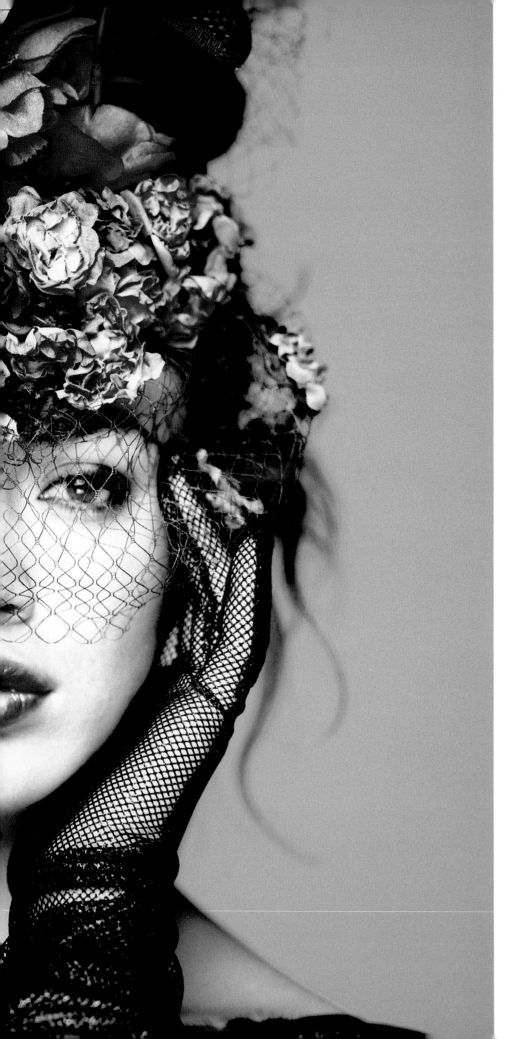

contents

lighting...

From the very first pictures captured on wet plates by nineteenth-century photography pioneers to the latest images recorded as digital files on a computer, people have always been the most popular subject for photography. For amateurs, the most common reason for taking out their cameras is to record for posterity, both the individuals who are important to them, and the special moments of their life. In the world of professional photography, too, portraits represent a significant proportion of commissioned work.

But what do we mean by a "portrait?" One English-language dictionary defines it as a "likeness of an individual, especially of the face." But while that definition is certainly one with which many would agree, it doesn't really do justice to the multitude of ways in which people can be portrayed in a picture. As the images in this book demonstrate, this is one of the most creative areas of photography you can be involved in.

the portrait market

Unfortunately, one of the largest markets for portraits is not renowned for being original in its approach. What has been considered "social" photography—family pictures to hang on the wall, engagement and christening shots, and, of course, the wedding album—has a reputation for being bland, formulaic, and uninspired. And while times are changing—with an increasing number of studios offering a more imaginative menu of shots—it's fair to say that the majority are still producing work of a traditional nature. Social photography, while important and demanding, is not what this book is about.

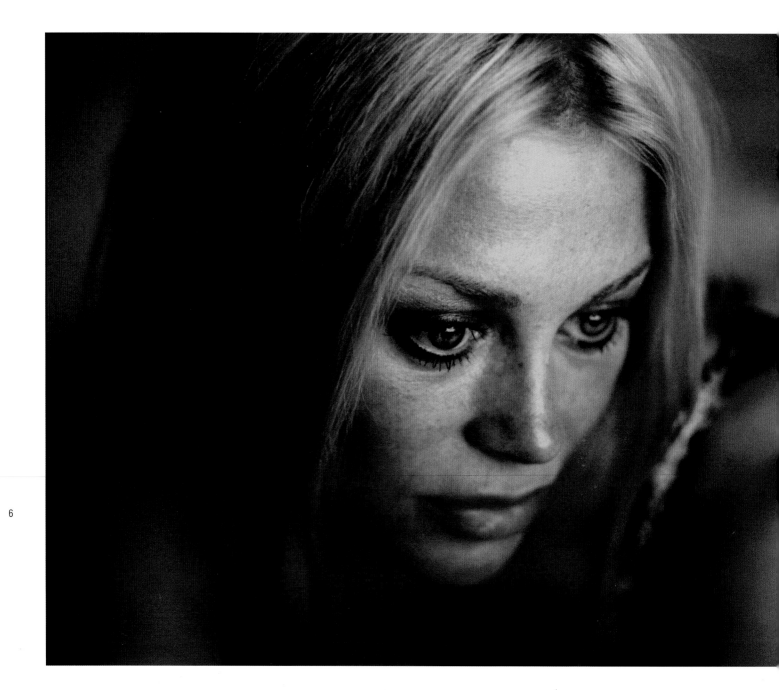

This book will examine some of the more innovative approaches being taken by creative photographers across a wide range of disciplines—including press, fine art, PR, stock, editorial, reportage, and celebrity.

Magazines and newspapers in particular are voracious consumers of people pictures, and though some are sourced through picture agencies, many are specially commissioned. With many photographers chasing glamorous, lucrative, and interesting work of this kind, there is strong competition, and your portfolio needs to be bursting with the right sort of images to convince prospective clients you have what it takes. It's a catch-22 situation: you won't get the jobs without the pictures, but how do you get the pictures if you're not getting the jobs? One way is to approach well-known faces and ask them if

they'd mind letting you take some pictures. Look them up in directories such as *Who's Who* and contact them. Maybe only one in 10 will say yes, but if you approach enough you'll be able to make a start. It's also a good idea to watch out for famous people who are visiting your neighborhood, perhaps to sign books or to appear in a show. They may be willing to spare you a few minutes of their time, which will enable you to add another picture or two to your portfolio.

One area in which some portrait professionals make a good living is in photographing actors, models, dancers, and the like, all of whom need attractive images for their promotional materials. A range of pictures is usually required, from simple headshots to more imaginative treatments—so it's an ideal way of trying out new ideas and stretching yourself.

Stock photography is an increasingly important source of people images, and picture libraries are crying out for portraits of all kinds—from straightforward studies to more conceptual images. Subjects of every age, sex, culture, and lifestyle are required, and if you're starting out you may have friends or family who will be willing to pose. Once you get established and your pictures start to sell, you can invest your earnings in hiring professional models to build up your stock of photographs further. This in time will generate yet more income.

Then there's the corporate world. People tend to figure strongly in annual reports, brochures, and catalogs these days, and pictures of everyone from the CEO down are required on a regular basis. Contacting businesses in your area can pay real dividends, and you may find it possible to specialize in this kind of work. Many professional photographers, though, prefer to tackle a wide range of subjects—they find it more interesting that way. But people figure in many of the pictures that are commissioned, and it's important to keep up with trends in posing and lighting in order to avoid your work looking dated—and that's where this book comes in.

style and approach

While formal portraiture still has its place, the style these days is more relaxed and informal. You see it everywhere: in magazines, in advertisements, in business communications. Gone are the stiff and starchy poses and frozen smiles that used to be so common. In their place is a softer, more natural approach that produces more realistic-looking portraits.

How do you get someone to relax when you've probably never met them before, have only 10 minutes to take the shot, and they don't particularly like being photographed anyway? The answer is to build up a rapport. Talk to them about their life, their job, their family, their interests. Get them chatting so their focus of attention is on the interaction with you, and not the photography. Whenever possible, plan ahead so that you have a clear idea about how you want to take the pictures, and get on with it efficiently and smoothly. There's nothing more unnerving for a subject than a photographer who doesn't seem to know what they're doing. Learn to work fast.

Many people don't have time for long sessions, so be prepared to get in, get your shot, and get out in under five minutes.

lighting matters

If you don't have much time then sophisticated lighting setups are obviously out—which is one of the reasons so many of the pictures in this book were taken using only one or two heads. Setting up a single umbrella or softbox is a relatively quick procedure. Once you've used it a couple of times and if you maintain the same distance, you may not even need to take a meter reading, since the camera settings will be in mind already. Keeping it simple has another advantage. The results look clean and contemporary. Styles change, and pictures date. You need only glance at a picture featuring a hair light, for instance, to see immediately that it's old-fashioned.

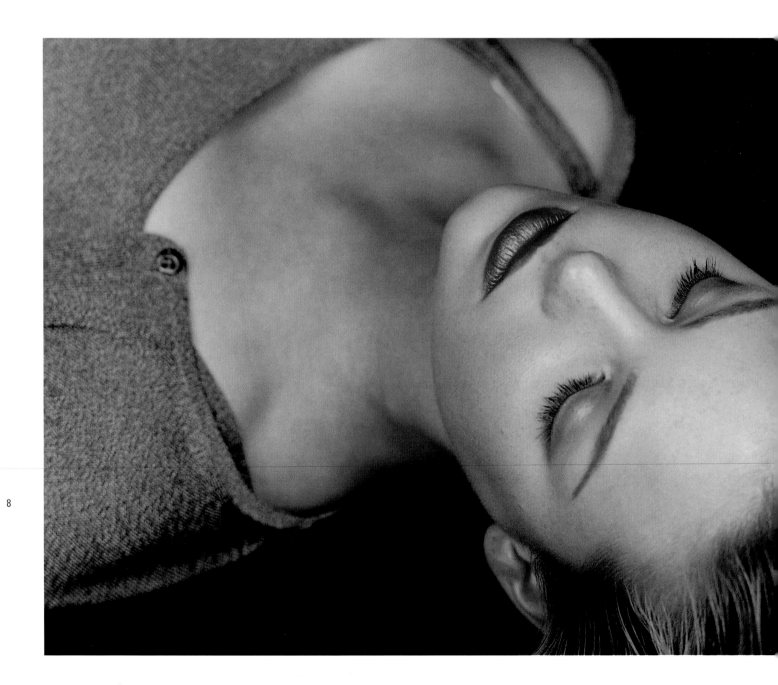

Another reason for a simple approach is that one light is also surprisingly versatile, depending on where you place it in relation to the subject, and whether or not you add a reflector to soften the shadows. With two lights you have more control over ratios, but also run the risk of overlighting the subject. Tried-and-tested setups include one above the camera and one below for "beauty" lighting, and either side of the camera at 45 degrees for even coverage. Naturally there will be times when you want to use more than two lights, but think carefully about what each light is contributing to the finished picture. If it adds nothing, don't use it.

Sometimes, though, you don't need to add any additional lighting at all because the ambient illumination is perfect. Both indoor and outdoor daylight have many moods, and with a bit of help from a poly board, they can give you a quality that's hard to reproduce artificially.

equipment considerations

Depending on usage, anything goes with portrait photography. In practice, the majority of people pictures are taken using medium-format equipment—either conventional or digital—because of the combination of quality, economy, and convenience that it gives. Digital SLRs are increasingly often the medium of choice for reportage-style work or where unobtrusive handling is the order of the day. View cameras are normally only employed where the image is to be used on a large scale or movements are required to introduce distortion.

... for portrait photography

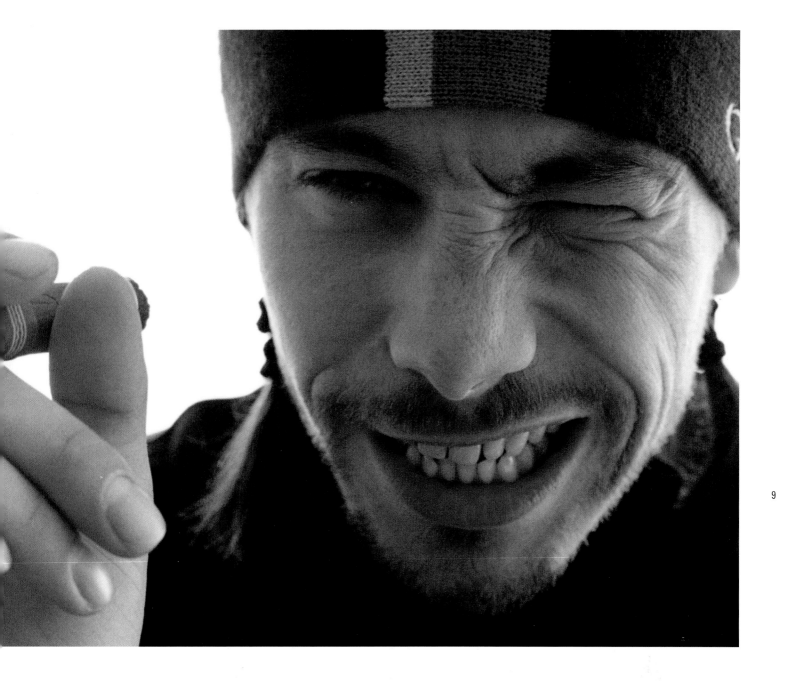

9

styling for portraits

What exactly does a stylist do?

The stylist's role has changed over the last five to 10 years, especially in fashion photography. Traditionally they were clothes stylists, there to say what was worn and how, checking the clothes were clean and worn correctly, and that they suited the subject. The stylist would also be in charge of the photograph's context, considering the background and the props to be involved. Today, because of the trend for natural-looking imagery, the overall "look" of the image—its total cohesion of approach—is of paramount importance. Thus the role of the stylist in being the "eyes" of the end-user (those who the image is directed at) is much more important. In magazine portraiture and fashion photography, the stylist is now credited along with the photographer, often being given equal status. The stylist will often spend a day or two of "prep," sourcing the clothes and considering the style of the finished image. The brief would be given by the client (the person/company paying for the photograph) or sometimes the photographer, but this is often vague (e.g. "modern, urban, and classy," or "industrial grunge") and it would be the job of the stylist to interpret that more specifically, briefing the makeup and hair stylist also. The stylist is always there throughout the shoot, checking the look—from overall approach to the details of how a collar might turn up, or a scarf might be tied—and the view of the background.

Is it possible to get one stylist who can do everything?

It's rare. Stylists tend to specialize in one area—hair, makeup, or clothes—although it's increasingly common to have one person doing both the hair and the makeup. This can work better when there's limited time and can save money on airfares and hotels when shooting on location. The closest you get to someone who does all three is an art director, who oversees all creative areas of a shoot, and who would have a definite view of what look they want. They will think about the whole picture—the context, the room set, the clothes—and arrange things using their awareness of style intricacies. The hair stylist, makeup artist, and clothes stylist work very much as a team—for example, if the model's wearing a turtleneck the stylist will ensure it's removed before large rollers go into the hair.

What can a makeup artist bring to a shoot?

It's often the makeup artist who is most aware of the lighting, since cosmetic products can melt under strong lights and constantly need checking. They will have expertise and experience of what makeup works best with various lighting setups, and they are able to create a different mood or look simply by changing the cosmetics.

What can a hair stylist contribute to a shoot?

The hair stylist is often simply briefed on the day. They will normally bring a large selection of hair-styling tools with them—everything from straighteners, tongs, rollers, and brushes to gels, spray, wigs, and hairpieces. This enables them to completely transform the appearance of the hair, and to make changes during the course of the shoot. Many celebrities prefer to bring along their own hair stylists.

What can a clothes stylist bring to a shoot?

Sometimes people will be photographed wearing their own clothes, and the services of a specialist clothes stylist will not be required. Where the intention is to create a certain look, it's essential to have someone who is up to date with fashion and who knows how to make clothes look good. Clothes stylists have contacts with fashion labels and can get clothes from their press contacts before they're in the stores. If the clothes are not going to have a credit—as is sometimes the case in portraiture—then the stylist will require a budget on top of the fee. The stylist will facilitate relationships with celebrities and fashion houses, who see the arrangement as mutually beneficial and will often encourage one celebrity to become associated with the label.

To what degree can a stylist create a look?

Portraits often don't need to be high fashion and a stylist will be able to create a modern, yet classic look. They provide general grooming and checking (who else will notice if a singlet is inside out?).

What skills will a good stylist have?

A good stylist should be able to address every job individually and work with the photographer and client to create something they are happy

with, without imposing themselves or their ideas. Sometimes a stylist can push a view on a person to the extent that they no longer retain a sense of self and as a result feel they can't carry the look off because it's not them. A stylist has to step back and look at the person and not let their own personal style interfere with the job in hand. It's about working with people to create the best ultimately for that person—so they need to be versatile. Their communication skills will be excellent. They will be able to convince people they look good, which helps them relax—making life easier for the photographer.

How do you go about finding a good stylist?

Stylists can be found at agencies that represent hair and cosmetics, and often get known through word of mouth. There are also a number of directories that list photographers, venues, agencies, and labels, as well as stylists. It's also worth tracking down stylists who want to test. Some are willing to offer their services free initially in exchange for prints with which they can build a portfolio of their work.

On what basis do stylists charge?

It depends on the experience of the stylist and the agent. They charge by the day and typically cost from $1,000 to $5,000, depending on the job and who the stylist is. Clothes stylists will also charge half that fee for the prep day (when they source the clothes).

making light work

understanding, measuring, and using light to create exciting and memorable images

Light is the single most important element in any picture. You try taking a picture without any! And it's the way you use light that often makes the difference between success and failure. You can have the most attractive or interesting subject in the world, get your exposure right, and focus perfectly, but if the lighting's not good you can forget it. However, it's astonishing how few photographers pay any real attention to light. Even professionals can be so eager to press the shutter release and get the shot in the bag, they don't really think about how to make the light work for them. Getting to know light, and being able to use it creatively, are essential skills for any photographer. One of the best ways of developing and deepening that understanding is to monitor the many moods of daylight. You might find yourself noticing how beautiful the light is on the shady side of a building, or coming in through a small window, or dappled by the foliage of a tree—and store that awareness and knowledge away for use when planning a shoot in the future. The most amazing thing about light is its sheer diversity: sometimes harsh, sometimes soft; sometimes neutral, sometimes rosy or blue; sometimes plentiful, sometimes in short supply.

more doesn't mean better

Taking pictures is easy when there's lots of light. You're free to choose whatever combination of shutter speed and aperture you like without having to worry about camera shake or subject movement—and you can always reduce it with a Neutral Density filter if there's too much.

But don't confuse quantity with quality. The blinding light you find outdoors at noon on a sunny day or bursting out of a bare studio head may be intense, but it's far from ideal for most kinds of photography. More evocative results are generally achieved when the light is modified in some way, with overall levels often much lower. With daylight, this might be by means of time of day—early morning and late evening being more atmospheric, or by weather conditions, with clouds or even rain or fog producing very different effects. Some of the most dramatic lighting occurs when opposing forces come together—such as a shaft of sunlight breaking through heavy cloud after a storm. In the studio, as well as the number of lights used and their position, it's the accessories you fit which determine the overall quality of the light.

controlling the contrast

For some situations and subjects you will want light that is hard and contrasty, with strong, distinct shadows and crisp, sharp highlights. Outdoors when it's sunny, the shadows are darker and shorter around noon, and softer and longer when it's earlier and later in the day. Contrasty lighting can result in strong, vivid images. However, the long tonal range you get in such conditions can be difficult to capture either digitally or on film. Care must be taken when shooting in such light so that no important detail is lost in light or dark areas.

This kind of strong contrast treatment is not always appropriate or suitable, however, and for many subjects and situations a light with a more limited tonal range that gives softer results may work better. Where you want to show the maximum amount of detail, or create a mood of lightness and airiness, with the minimum of shadows, the soft lighting of an overcast day or a large softbox is unbeatable. The degree of contrast also depends on the direction from which the light is coming. In every picture you are using light to reveal something about the subject—texture, form, shape, weight, color, or even translucency. So look carefully at what you are going to photograph, and consider what you want to convey about the subject, then start to organize the illumination accordingly.

light isn't white

We generally think of light as being neutral or white, but in fact it varies considerably in color. You need only think about the orange of a sunrise or the blue in the sky just before night sets in. The color of light is measured in what are known as Kelvins (K), and the range of possible light colors makes up what is known as the Kelvin scale. Standard daylight-balanced film is designed to be used in noon sunlight, which typically has a temperature of 5,500 K. Electronic flash is the same. However, if you use daylight film in light of a lower color temperature you'll get a warm, orange color, while if you use it in light of a higher temperature, you'll get a cool, blue tonality. Such casts are generally regarded as wrong, but if used intentionally they can give a shot more character than the blandness of a clean white light. Shooting digitally of course allows you to set the white balance manually—in which case you can experiment with the setting until you get the color you find most appropriate.

daylight moods

One option for certain kinds of work is to run your studio on daylight—and some professionals do just that. Consider the advantages: the light you get is completely natural, unlike flash you can see exactly what you're getting, and it costs nothing to buy or run. When working outdoors, light can be controlled by means of large white and black boards which can be built around the subject to produce the effect required. Indoors, you might want to choose a room with north-facing windows, because no sun ever enters and the light remains constant throughout the day. However, this may be a little cool for color work, giving your shots a bluish cast. If so, simply fit a pale orange color-correction filter over the lens to warm things up; alternatively, adjust the white balance setting as required. Rooms facing other points of the compass will see changes of light color, intensity, and contrast throughout the day. When the sun shines in, you'll get plenty of warm-toned light that will cast distinct shadows. With no sun, light levels will be lower, shadows softer, and the color temperature more neutral.

The room's windows also determine how harsh or diffuse the light will be. Having a room with at least one big window, such as a patio door, will make available a soft and even light. The effective size of the window can easily be reduced for a sharper, more focused light, by means of curtains or black card. In the same vein, light from small windows can be softened with sheer drapes. The ideal room would also feature a skylight, adding a soft, downward light.

Whatever subject you're shooting, you'll need a number of reflectors to help you make the most of your daylight studio—allowing you to bounce the light around and fill in shadow areas to contrast.

studio control

Daylight studios are great, but they have obvious disadvantages: you can't use them when it's dark; you can't turn the power up when you need more light; and you don't have anywhere near the same degree of control you get when using studio heads. Being able to place lights exactly where you want them, reduce or increase their output at will, and modify the quality of the illumination according to your needs means the only limitation is your imagination.

making light work

...continued

Some photographers seem to operate on the basis of "the more lights the better," using all their lights all the time. But there's a lot to be said for simplicity, and some of the best portraits are taken using just one perfectly positioned head. By using different modifying accessories with the head, you can alter the quality of its output according to your photographic needs. Before going on to more advanced setups, it pays to learn to make the most of just a single light source—trying it in different positions and at different heights. If you want to soften the light further and give the effect of having a second light of lower power, a simple white reflector is all you need.

Of course, having a second head does give you many more options—as well as using it for fill-in you can place it alongside the main light, put it over the top of the subject, or wherever works well. Having two lights means you can also control the ratio between them, reducing or increasing their relative power to control the contrast in the picture. For many subjects a lighting ratio of 1:4 (one light has one quarter of the power of the other) is ideal, but there are no hard-and-fast rules.

In practice, many photographers will need to have at least three or four heads in their armory, and unless advanced setups are required or enormous firepower, that should be sufficient for most situations. However, it is worth reiterating that it is all too easy to overlight a subject, with unnatural and distracting shadows going in every direction. So before you introduce another light, ask yourself what exactly it adds to the image—and if it adds nothing, don't use it.

tungsten or flash?

This is the main choice when buying studio heads, and both have pros and cons. Tungsten units tend to be cheaper and have the advantage of running continuously, allowing you to see exactly how the light will fall in the finished picture. However, the light has a strong orange content, typically around 3,400 K, requiring a tungsten white balance setting or the use of tungsten film. Tungsten lights can also generate enormous heat, making them unsuitable for certain subjects. Flash heads are more commonly used because they are much cooler to run, produce a white light, and have a greater light output. Many studios have both types, and a decision about which to use is based on the requirements of the job in hand.

accessories that assist

Every bit as important as the lights themselves are the accessories you fit on them. Few pictures are taken with just the bare head as the light goes everywhere, which is not what you want. To make the light more directional you can fit a dish reflector, which narrows the beam and allows you to restrict it to certain parts of your subject. A more versatile option is provided by barn doors, which have four adjustable black flaps that can be opened out to accurately control the spill of the light. If you just want a narrow beam of light, try fitting a snoot—a conical black accessory which tapers to a concentrated circle.

Other useful accessories include spots and fresnels, which you can use to focus the light, and scrims and diffusers to reduce the harshness. If you want softer illumination, the light from a dish reflector can be bounced off a large white board or, more conveniently and especially for location work, fired into a special umbrella. If that's not soft enough for you, invest in a softbox—a large white accessory that mimics windowlight and is perfect for a wide range of subjects. The bigger the softbox, the more diffuse the light.

measuring light

Over recent years the accuracy of in-camera meters has advanced enormously. By taking separate readings from several parts of the subject, and analyzing them against data drawn from hundreds of different photographic situations, they deliver a high percentage of successful pictures. However, the principal problem with any kind of built-in meter remains the fact that it measures the light reflected back from the subject—so no matter how sophisticated it may be, it will be prone to problems in tricky lighting situations, such as severe backlighting or strong sidelighting.

An additional complication is that integral meters don't know what you're trying to do creatively. So, while you might prefer to give a little more exposure so that the shadows have plenty of detail, your camera's meter will come up with a "correct" reading that produces bland results. If shooting digitally, using the RAW format will allow you to make some adjustments to exposure during the postproduction stage.

For all these reasons, any self-respecting professional photographer or serious amateur will invest in a separate light meter, which will give them full control over the exposure process—and 100 percent accuracy. Although you can make adjustments at the postproduction stage when shooting digitally, it's good practice to get it right in-camera. Handheld meters provide you with the opportunity to do something your integral meter never could—take an "incident" reading of the light falling onto the subject. With a white "invercone" dome fitted over the sensor, all the light illuminating the scene is integrated, avoiding any difficulties caused by bright or dark areas in the picture. When using filters, you can either take the reading first and then adjust the exposure by the filter factor if you know it, or the filter over the sensor when taking a measurement.

Those seeking unparalleled control over exposure should consider buying a spot meter, which allows you to take a reading from just one percent of the picture area—although many digital SLRs now feature a spot meter mode.

Many of the more expensive handheld meters, both incident and spot, have a facility for measuring electronic flash as well. For those who don't feel the need for an ambient meter, separate flash-only meters are available. The benefit of having a meter that can measure flash is obvious. In the studio it allows you to make changes to the position and power of lights and then quickly check the exposure required. When using a portable electronic gun, you can use it to calculate the amount of flash required to give a balanced fill-in effect.

Incident flash meters are used in exactly the same way as when taking an ambient reading. The meter is placed in front of the subject, facing the camera, and the flash fired. This can usually be done from the meter itself by connecting it to the sync cable, and pressing a button. Another useful feature that's widely available allows you to compare flash and ambient readings—perfect if you're balancing flash with ambient light or want to mix it with tungsten. Some of the more advanced flash meters can also total multiple flashes—ideal if you need to fire a head several times to get a small aperture for maximum depth of field.

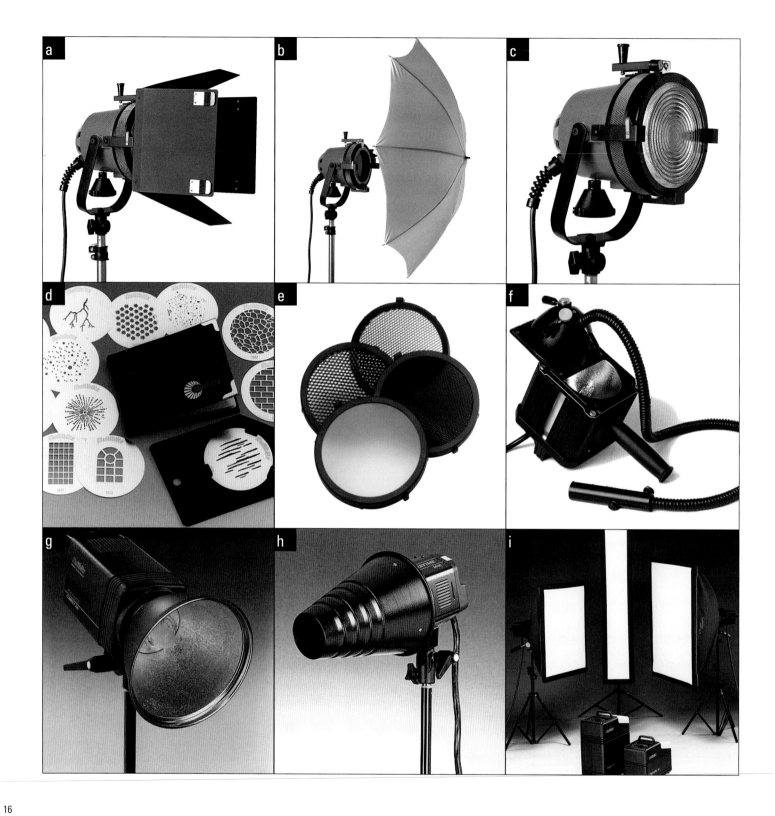

glossary of lighting terms

Acetate
Clear plastic-like sheet often color-tinted and fitted over lights to create a specific color cast

Ambient light
Naturally occurring light

Available light
See Ambient light

Back-projection
System in which a transparency is projected onto a translucent screen to create a backdrop

Barn doors (a)
Set of four flaps that fit over the front of a light and can be adjusted to control the spill of the light

Boom
Long arm fitted with a counterweight that allows heads to be positioned above the subject

Brolly (b)
See Umbrella

CC filters
Color-correction filters used for correcting any imbalance between films and light sources

Continuous lighting
Sources that are "always on," in contrast to flash which only fires briefly

Cross-processing
The use of unconventional processing techniques, such as developing color film using transparency chemistry. Similar effects can be achieved using image-editing software if shooting digitally

Diffuser
Any kind of accessory that softens the output from a light

Effects light
Light used to illuminate a particular part of the subject

Fill light
Light or reflector designed to reduce shadows

Fish fryer
Extremely large soft box

Flash head
Studio lighting unit that emits a brief and powerful burst of daylight-balanced light

Flag
Sheet of black card used to prevent light falling on parts of the scene or entering the lens and causing flare

Fluorescent light
Continuous light source that often produces a green cast—though neutral tubes are also available

Fresnel (c)
Lens fitted to the front of tungsten lighting units that allows them to be focused

Giraffe
Alternative name for a boom

Gobo (d)
Sheet of metal or card with areas cut out, designed to cast shadows when fitted over a light

HMI
Continuous light source running cooler than tungsten but balanced to daylight and suitable for use with digital cameras

Honeycomb (e)
Metallic grid that fits over a lighting head producing illumination that is harsher and more directional

Incident reading
Exposure reading of the light falling onto the subject

Joule
Measure of the output of flash units, equivalent to one watt-second

Kelvin
Scale used for measuring the color of light. Daylight and electronic flash are balanced to 5,500 K

glossary of lighting terms

...continued

Key light
The main light source

Kill spill
Large flat board designed to prevent light spillage

Lightbrush (f)
Sophisticated flash-lighting unit fitted with a fiber-optic tube that allows the photographer to paint with light

Light tent
Special lighting setup designed to avoid reflections on shiny subjects

Mirror
Cheap but invaluable accessory that allows light to be reflected accurately to create specific highlights

Mixed lighting
Combination of different-colored light sources, such as flash, tungsten, or fluorescent

Modeling light
Tungsten lamp on a flash head which gives an indication of where the illumination will fall

Monobloc
Self-contained flash head that plugs directly into the mains (unlike flash units, which run from a power pack)

Multiple flash
Firing a flash head several times to give the amount of light required

Perspex
Acrylic sheeting used to soften light and as a background

Ratio
Difference in the amount of light produced by different sources in a setup

Reflector
1) Metal shade around a light source to control and direct it **(g)**
2) White or silvered surface used to bounce light around

Ringflash
Circular flash tube that fits around the lens and produces a characteristic shadowless lighting

Scrim
Any kind of material placed in front of a light to reduce its intensity

Slave
Light-sensitive cell that synchronizes the firing of two or more flash units

Snoot (h)
Black cone that tapers to concentrate the light into a circular beam

Softbox (i)
Popular lighting accessory producing extremely soft light. Various sizes and shapes are available—the larger they are, the more diffuse the light

Spill
Light not falling on the subject

Spot
A directional light source

Spot meter
Meter capable of reading from a small area of the subject—typically 1–3 degrees

Stand
Support for lighting equipment (and also cameras)

Swimming pool
Large softbox giving extremely soft lighting (see also Fish fryer)

Tungsten
Continuous light source

Umbrella (b)
Inexpensive, versatile, and portable lighting accessory. Available in white (soft), silver (harsher light), gold (for warming), and blue (for tungsten sources). The larger the umbrella, the softer the light

practicalities

How to gain the most from this book

The best tools are those that can be used in many different ways, which is why we've designed this book to be as versatile as possible. Thanks to its modular format, you can interact with it in whichever way suits your needs at any particular time. Most of the material is organized into self-contained double-page spreads based around one or more images. In each case there is a three-dimensional diagram that shows the lighting used—based on information supplied by the photographer. You can copy the arrangement if you want to produce a shot that's similar. Naturally the diagrams should only be taken as a guide, as it is impossible to accurately represent the enormous variety of heads, dishes, softboxes, reflectors, and so on that are available, while using an accessible range of diagrams, nor is it possible to fully indicate lighting ratios and other such specifics. In practice, however, differences in equipment, and sometimes scale, should be small, and will anyhow allow you to add your own personal stamp to the arrangement you're seeking to replicate. In addition you'll find technical details about the use of camera, exposure, and lens, along with any useful hints and tips.

icon key

- ⊛ Photographer
- ⊘ Client
- ◉ Possible uses
- ◍ Lens
- ◌ Exposure
- ◎ Type of light

understanding the lighting diagrams

Equipment key

standard head

standard head with snoot

spot

barn doors

honeycomb

flood

strip flash

soft box

umbrella

daylight source

large format camera

medium format camera

35mm camera

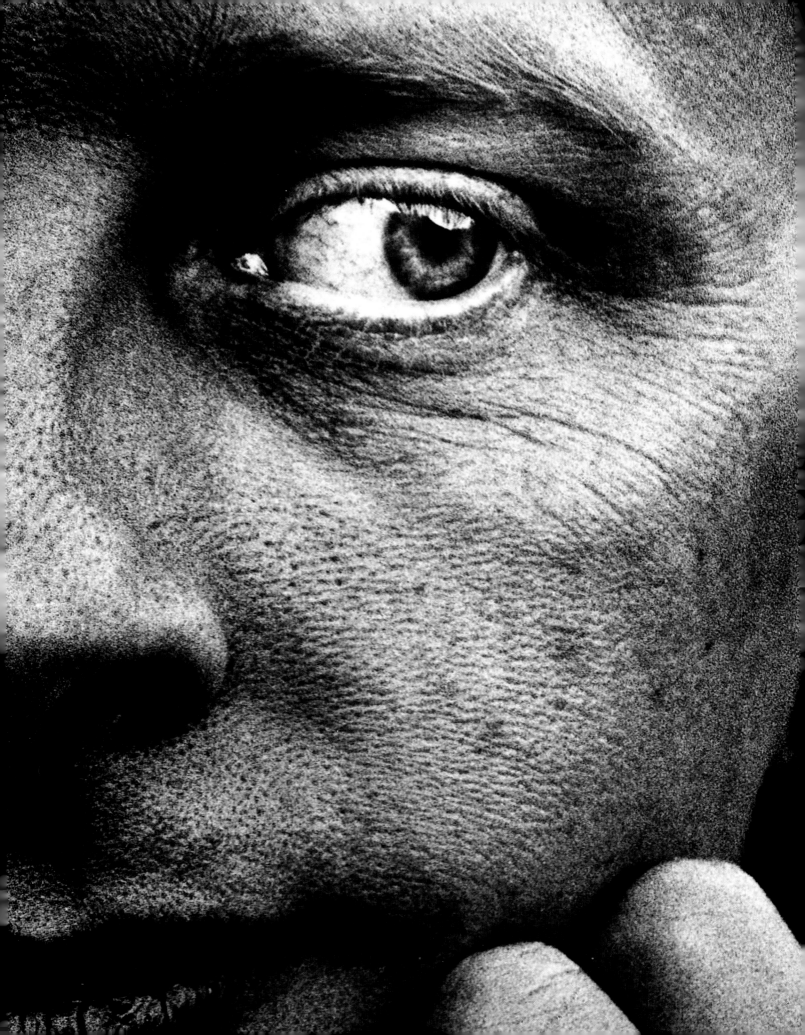

outdoor / ambient

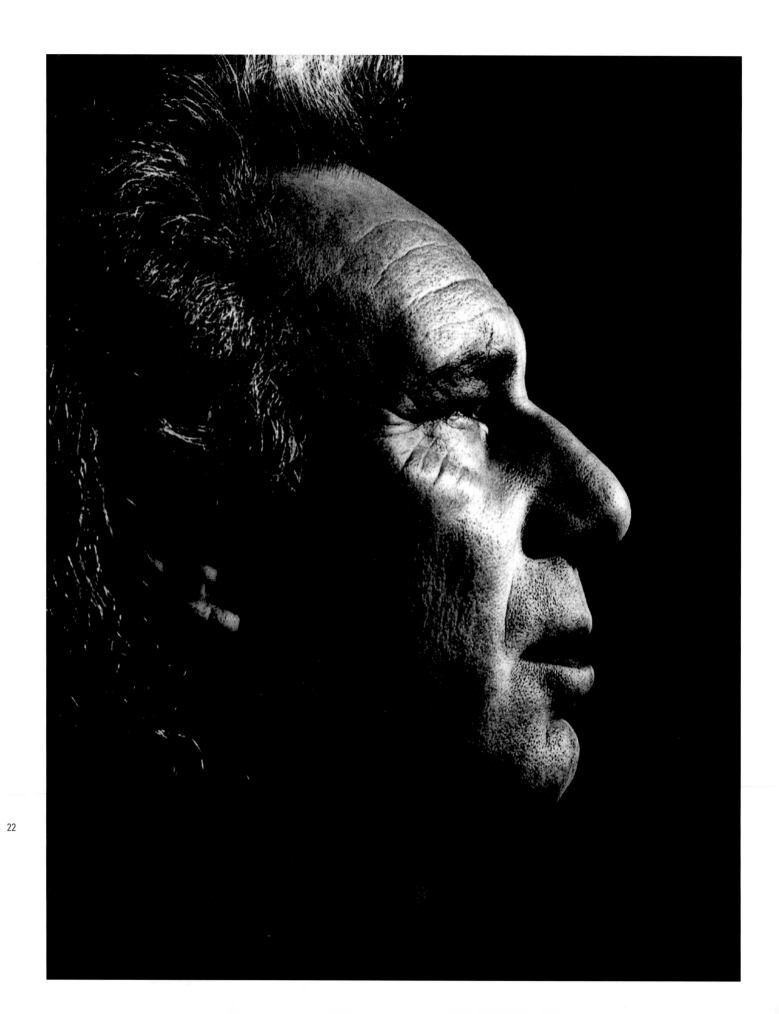

One of the most powerful ways of photographing someone with strong features is to shoot them in profile—and this picture shows how effective the approach can be when done well.

By asking his subject to face a window, and by positioning him in front of a black door, the photographer has defined the outline of the face perfectly by means of the slight backlighting. The window has clear, unbroken light falling onto the face, and the door provides a background too dark to register. The effect has been further enhanced by printing the image on a contrasty paper. Any residual background detail has burnt in, and it has been given a final boost digitally.

Fin Costello

El Pais newspaper

Editorial

50mm

1/250sec at f/5.6

Window light

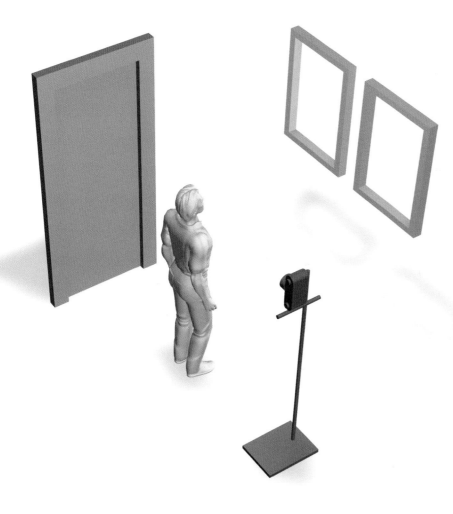

strong profile

Hard printing helps make the best of a super profile shot.

It's hard to create soft, delicate, and flattering light like this in the studio—and, yes, this picture was taken using daylight. The actress Angelina Jolie is standing just inside a doorway, with a black paper background behind her. Standing outside is photographer Jeff Dunas, with two 4 x 8ft (1.2 x 2.4m) white panels and a white wall about 12ft (3.6m) behind him reflecting sunlight back at the subject.

"When you're photographing a celebrity wearing glasses and you don't have much time, you've got to be careful with flash," Dunas warns. "There's always a chance you're going to get reflections you're not aware of. With daylight you can concentrate on the subject without having to worry about things like that."

() Jeff Dunas
() *Max* magazine
() Various
() 150mm
() 1/125sec at f/4
() Electronic flash and daylight

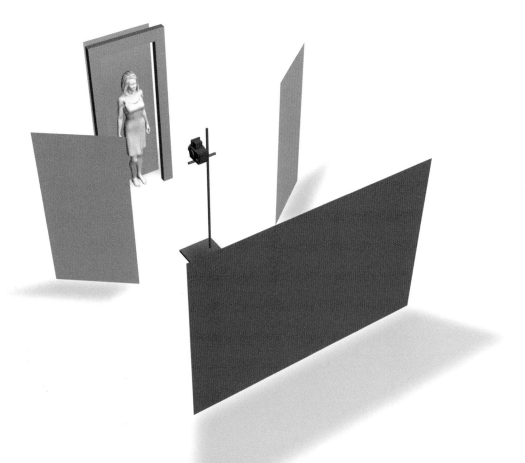

creating meaningful images

"What I'm looking to do is have something very meaningful and very important with the subject that creates the content of the picture," reveals Dunas. "Sometimes I'm given just five minutes with a person, and I need to make an instant connection with them. My tendency is to work for a short but intense period of time where I'm focused like a laser on getting what I want. You need to make that subject reveal something of themselves to you. It's a brief thing, and it all happens in a moment."

angelina jolie

Placing your subject facing out of a doorway gives soft illumination.

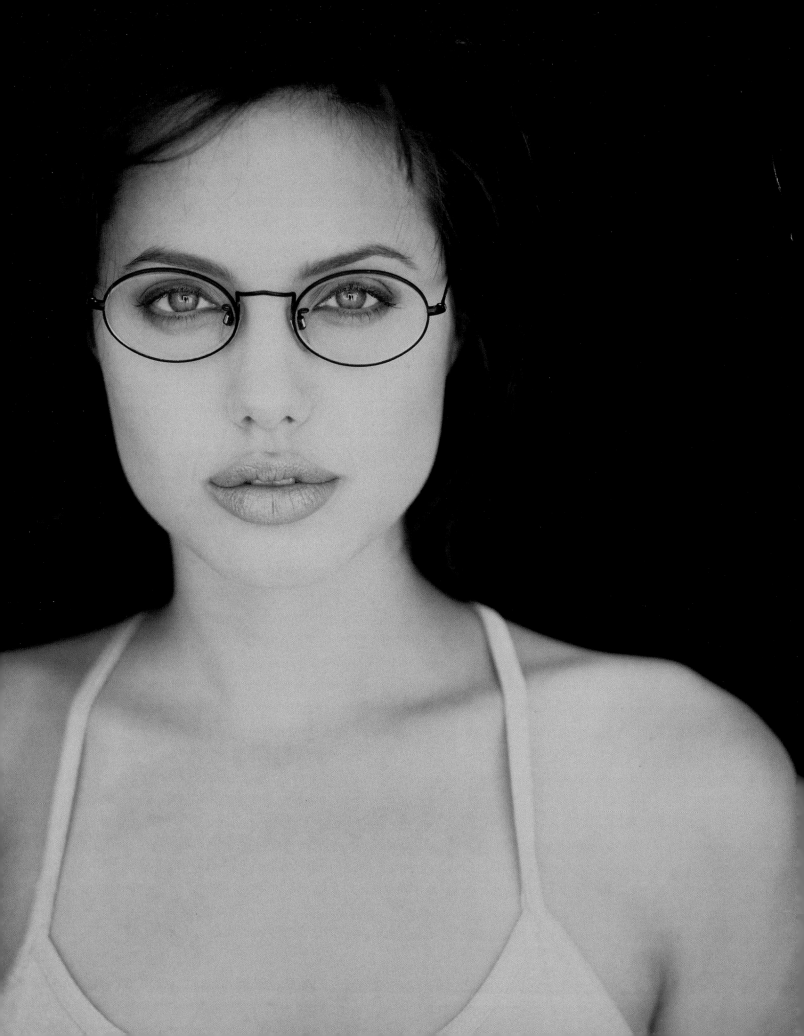

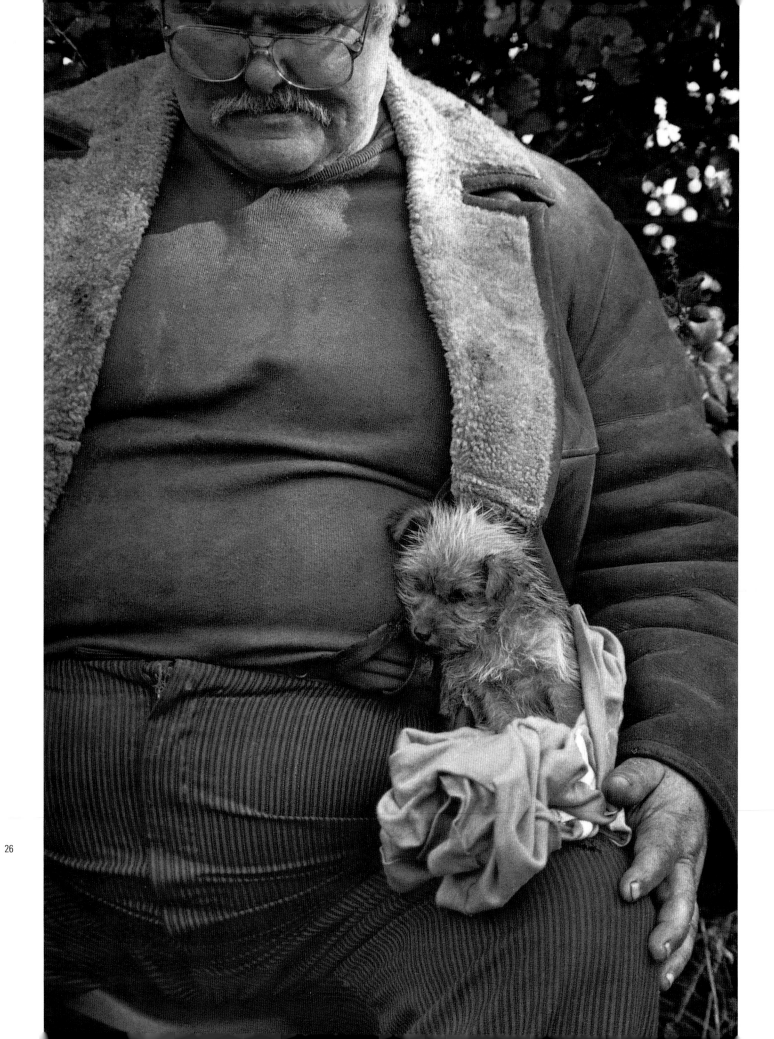

As part of a project on the gypsy community in the UK, Jo McGuire traveled around capturing reportage-style portraits of some of the leading characters. Shooting handheld with 35mm equipment, she sought to record them in as natural and honest a way as possible. This meant working entirely with daylight, and making the most of its many moods to produce a lasting testimony to the rapidly changing way of life. The two pictures here are typical of her style.

The picture of Ezzi Taylor with his dog is wonderfully evocative, thanks in no small part to the late afternoon light raking across from behind. Under normal circumstances this might have been too harsh, but happily a camp fire was burning just in front of the photographer, and the flickering flames balanced the lighting perfectly.

(人) Jo McGuire

(つ) Personal project

(◉) Exhibition

(◎) 85mm

(⏱) 1/125sec at f/5.6

(💡) Ambient light and firelight

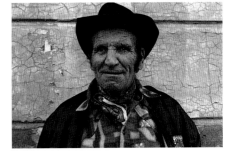

gypsy kings

Careful choice of ambient lighting conditions contributes to the overall feel of the picture.

Kevin Price has been shot standing in front of a cracked wall, which seems to echo the lines on his face. The soft light of an overcast day produces flat and sympathetic illumination, while the white canopy of a stand behind the photographer acts as a natural reflector to lighten the face and put a catchlight in the eye.

"The light was dreadful," says Llewellyn Robins of the time he came to take this picture. "It was a flat, gray, overcast day, with no hint of sun whatsoever."

However, knowing that a problem is really only an opportunity in disguise, he decided to create his favored kind of lighting by taking his subject on location to a barn. Placing him 6ft (1.8m) inside the barn, the light coming in was wonderfully directional—like having an enormous softbox the size of which can be controlled by how far open the doors are. The resulting illumination is deliciously soft and frontal, and it also reveals the texture of the graphite, metal, and glass sculpture the man is holding. Careful printing was required to darken down the edges and extract every last drop of quality from the picture.

Llewellyn Robins

Private commission

Publicity

80mm

1/4sec at f/4

Ambient light

man with sculpture

28

Finding some way of creating directional lighting on an overcast day produces a softer, more attractive result.

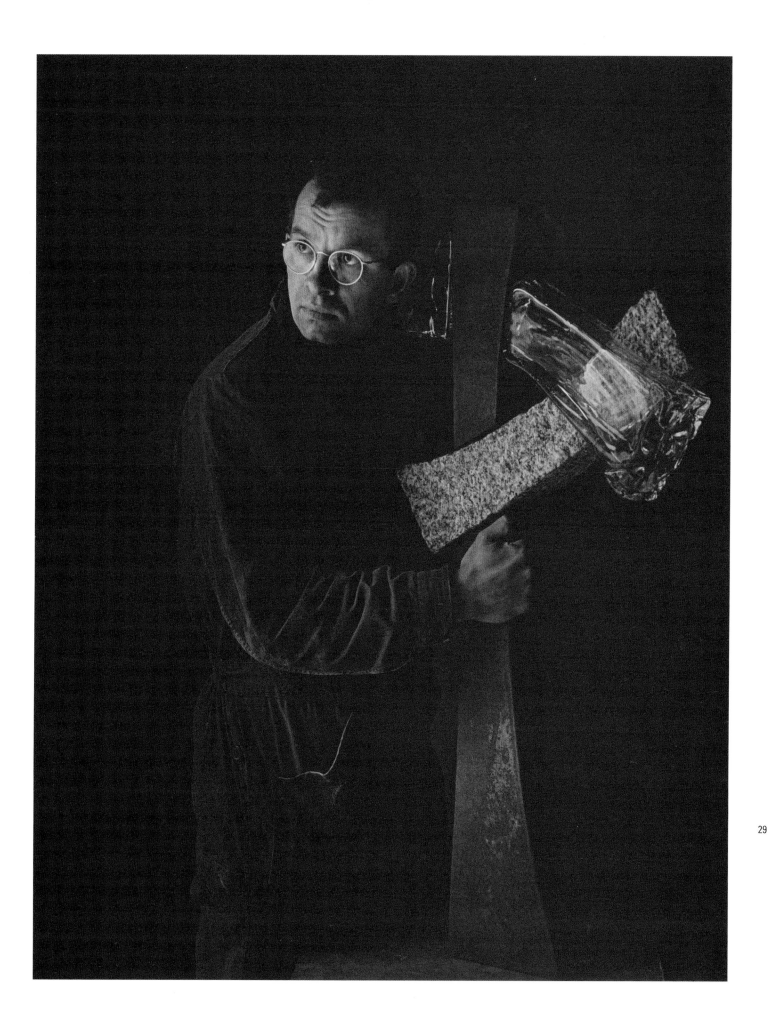

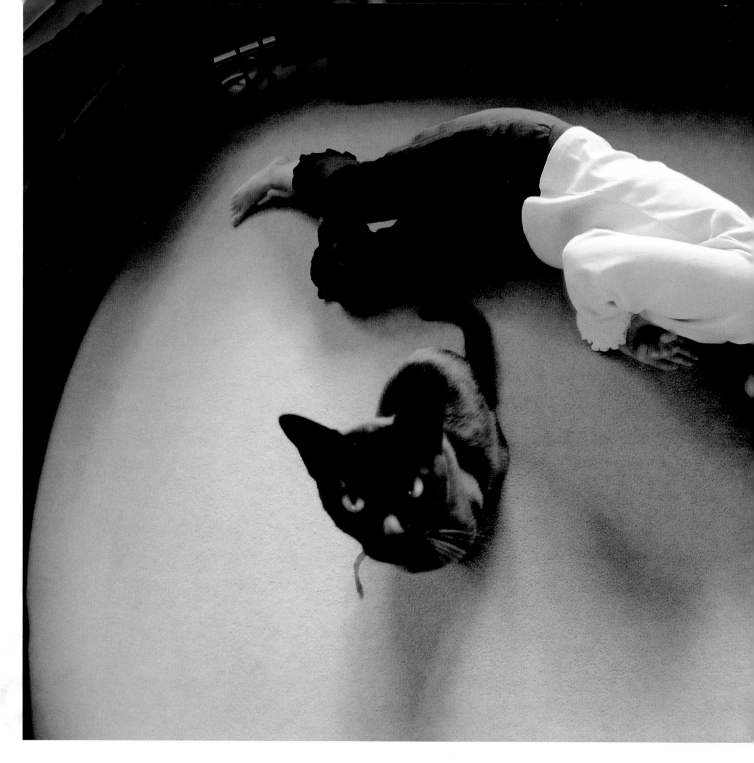

amelia with cat

The use of a fisheye lens draws us into Amelia's world and emphasizes the cat's face.

The aim of this session was to capture a moment in the life of Amelia and the photographs were all taken at her home. "I decided to use a recently acquired Nikon D70," explains Nigel Harper, "and to shoot everything using available light with reflectors and a 50mm f1.4 lens."

However this particular image was taken with Nikon's 10.5 mm fisheye. Harper continues, "As Amelia lay on the carpet, I quickly placed the cat into the frame. Then, I stood over Amelia, balancing a silver reflector against my legs, and, while trying to keep the cat's attention, I captured the shot".

The resulting photographs were presented in a contemporary, coffee table book.

- Nigel Harper
- Personal project
- Various
- 10.5mm (efl 16mm)
- 1/60sec at f/4
- Ambient light and reflector

"'Girl from Reading' is about a 17-year old woman and how she has chosen to represent herself to the world. Abi is proud of her look and why shouldn't she be? She has a look of the moment and that's what interested me," explains Paul Wenham-Clark. "She prefers to stand out and make a public statement about herself. She is defining her character and announcing her arrival as a new adult woman on the scene. She is obviously no shrinking violet.

"I wanted the image to simulate a captured moment from which the viewer can imagine a life beyond the frame. Does she hang out with her friends in the park or is she meeting a boy? The image is contrived but not styled. Abi is wearing exactly what she would normally wear. The park and the repeating pattern of the housing estate place her in her territory and give rise to the story. I deliberately did not include her eyes within the frame, as we would instantly be drawn to them. We would start to read her emotions and overlook other areas of the image.

"Instead, I hoped the viewer would study the fine detail and as a result formulate an opinion of her character from this. I hope it makes older viewers think about what it must be like to be part of Abi's generation, where computers and cellphones have always existed and reality TV is mainstream entertainment."

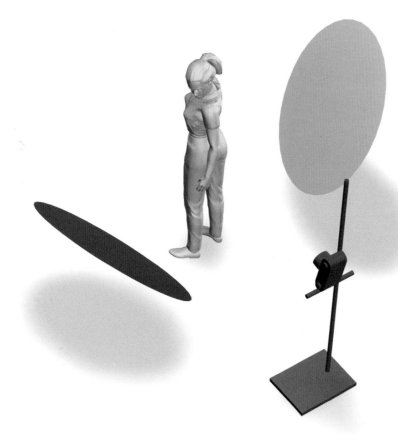

32

(人) Paul Wenham-Clark

(↻) Personal project

(◈) Various

(◉) 24–75mm

(⏱) 1/30sec at f/22

(💡) Ambient light and reflectors

girl from reading

Not being able to see the subject's eyes takes our focus away from the girl's emotions and forces us to concentrate on her surroundings.

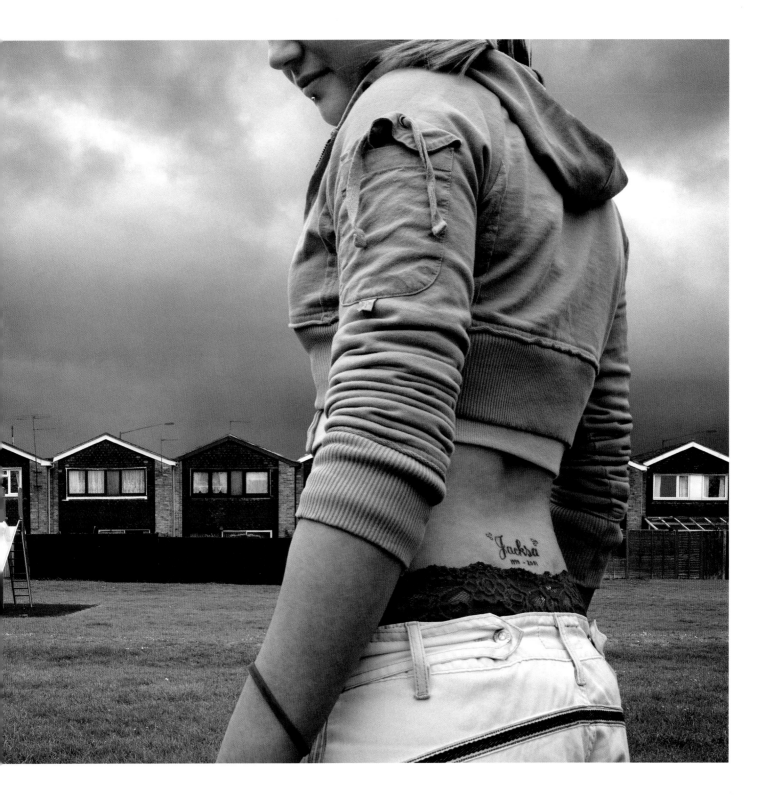

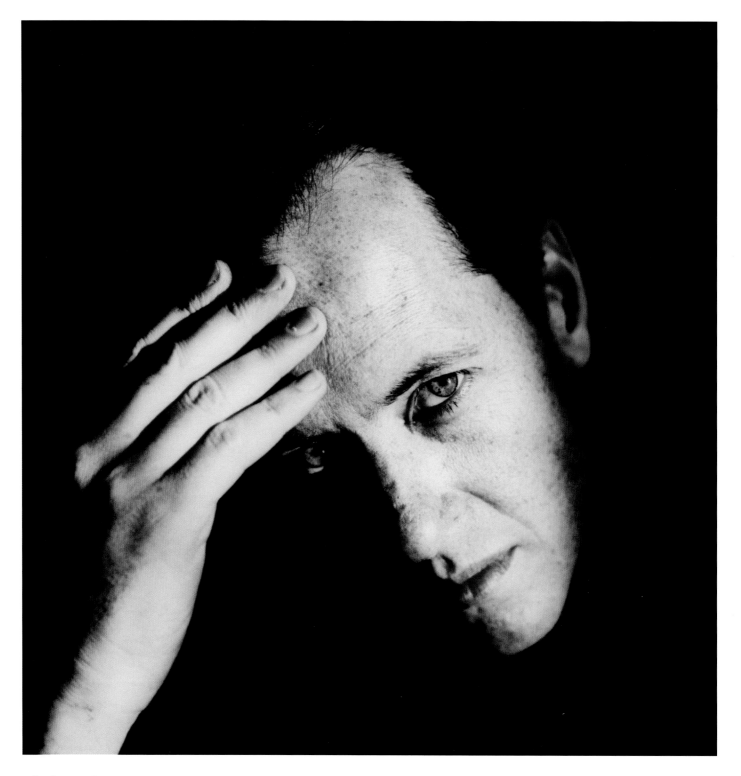

richard e. grant

Late evening sun picks out the subject with a dramatic shaft of sunlight.

The blue piercing eyes peering out from a disembodied head create such drama, it looks as if the subject might have been lit by a spotlight. In a sense he was; the light is provided by a shaft of late afternoon sun which is streaming through a window to the right of and behind the photographer; this produces a gorgeous "wraparound" effect. For this type of effect, the model must only wear black clothes.

The contrast of the shot was enhanced by cross-processing the transparency film in C41 chemistry—this process also had the advantage of losing all of the detail in the background, which might otherwise have been distracting.

Matt Moss

Personal project

Portfolio

110mm

1/125sec at f/8

Window light

An overcast day such as this, with heavy toplight, would not normally be used for outdoor portraiture, as the shadows are less than flattering. However, Marianne Wie wanted an angry, severe, unhappy expression, and deliberately chose conditions that enhanced that feeling. The only addition was an improvised reflector—a double bedsheet which she hung on the right-hand side of the frame to create a little contrast. The finished image was sepia-toned to give an old-fashioned feel.

Marianne Wie

Personal project

Editorial

80mm

1/30sec at f/5.6

Overcast daylight

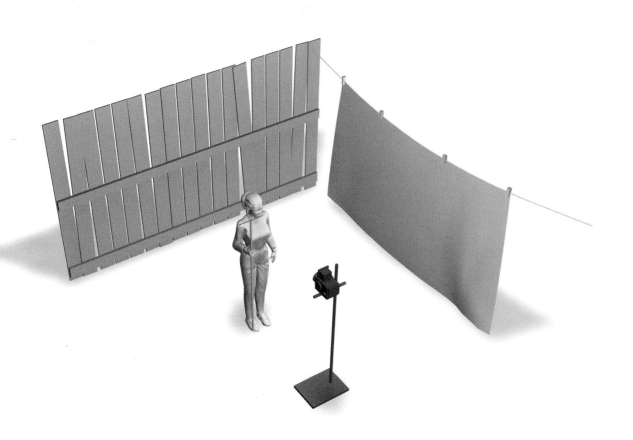

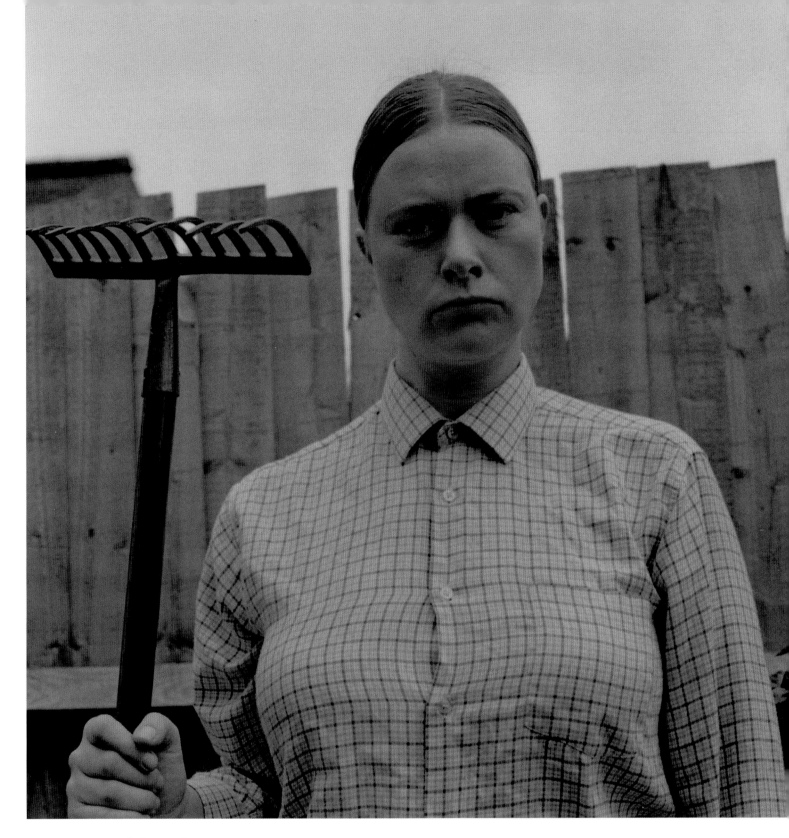

woman with rake

Drawing her inspiration from the painting *American Gothic* by Grant Wood, Marianne Wie created this self-portrait in her garden—setting the camera up on a tripod and getting a friend to fire the shutter for her.

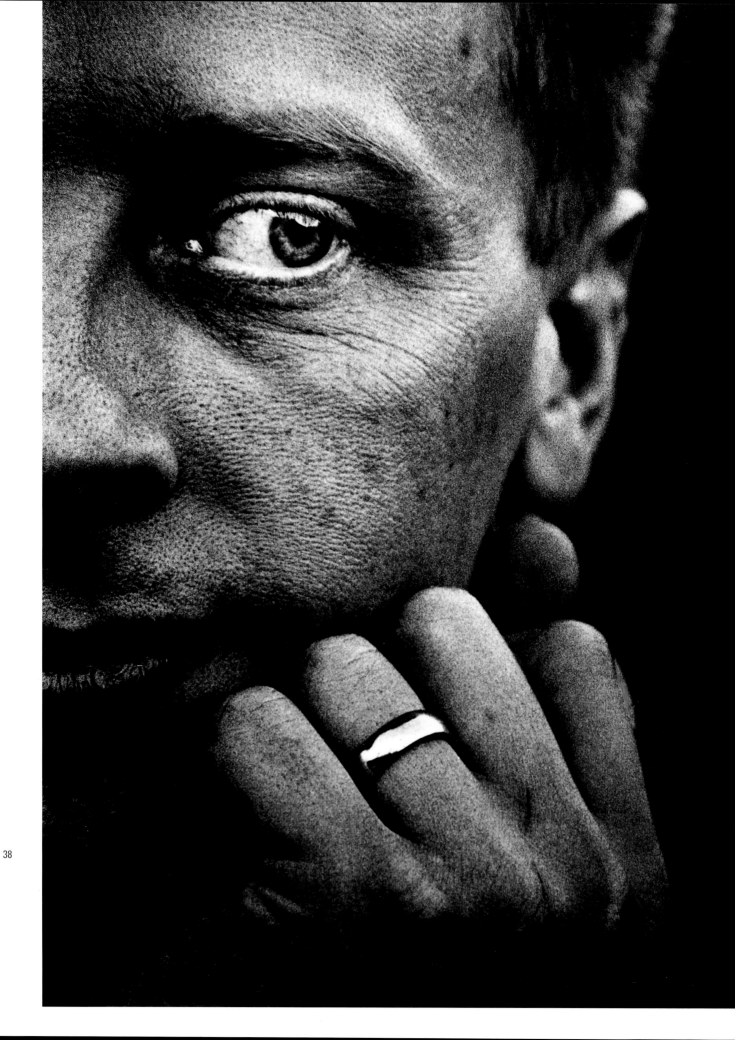

Cropping tightly into the face is always guaranteed to create an image with impact—and this shot is no exception. Your attention goes immediately to the eye, thanks in part to the graphic treatment, with the edges of the picture printed to appear really dark. Surprisingly, the picture was taken as part of the coverage of a wedding—hence the ring—further evidence of the degree to which social photography is increasingly drawing upon advertising and fashion styles.

In fact the original shot included more of the face, but the photographer decided to crop in even more tightly at the printing stage. Initially prints featured a full tonal range, but a much more contrasty treatment was tried and worked well, using Grade 5 paper. The lighting could not have been more simple, with the subject standing outdoors late in the evening of an overcast day. The catchlight in the eye is the sky.

In retrospect, Nigel Harper wonders whether he should have asked the subject to look directly at the camera, rather than to the side. "I've done similar shots where the subject is staring straight at you," he says, "and they seem to be more powerful. I just wanted to try something a little different."

⍟ Nigel Harper

☺ Private commission

◉ 28–80mm

◯ 1/60sec at f/4

◎ Ambient light

the groom

Bold cropping, limited depth of field, and contrasty printing produce a literally "eye-catching" image.

available-light press photography

Making the most of existing lighting allows press images for use in newspapers to be captured quickly and easily.

Taking pictures of people for publication in a newspaper or periodical can be a challenging business. Often you have no more than a few minutes, so there's not enough time to set up additional lighting, yet picture editors demand images with a certain amount of subtlety. Using a burst of fill-in flash from a gun attached to the camera is one way of ensuring the subject is fully illuminated—but the images all too often are flat and uninteresting as a result. The secret lies in making the most of whatever lighting already exists in the scene; and placing the subject whenever possible in literally the right light. Through developing this skill, Pauline Neild has become a sought-after contributor to national and regional newspapers.

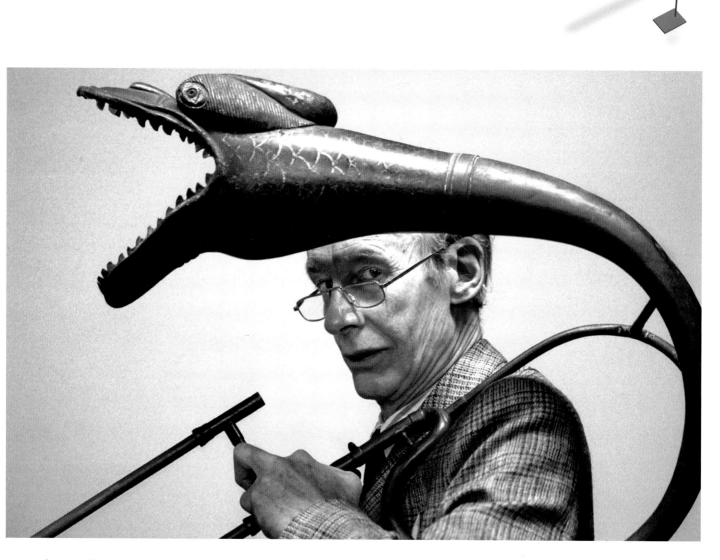

ancient instrument

One of the best ways of concentrating attention on the most important part of the picture is to frame it. Here, Neild has used an ancient musical instrument relating to the subject to provide a frame and dramatic foreground interest. The picture was taken in a medium-sized basement and, because there was no opportunity to set up additional lighting, she had to make use of the strip lights on the ceiling. However, by positioning the subject carefully in front of an area of white wall, she was able to contrast the face effectively against the shadowed areas of the instrument. It was then simply a matter of waiting for the right expression and firing the shutter.

- ⓐ Pauline Neild
- ⓒ *Times Educational Supplement* newspaper
- ⓟ Press
- ⓡ 28–105mm (at 50mm)
- ⓣ 1/15sec at f/4
- ⓛ Ambient light

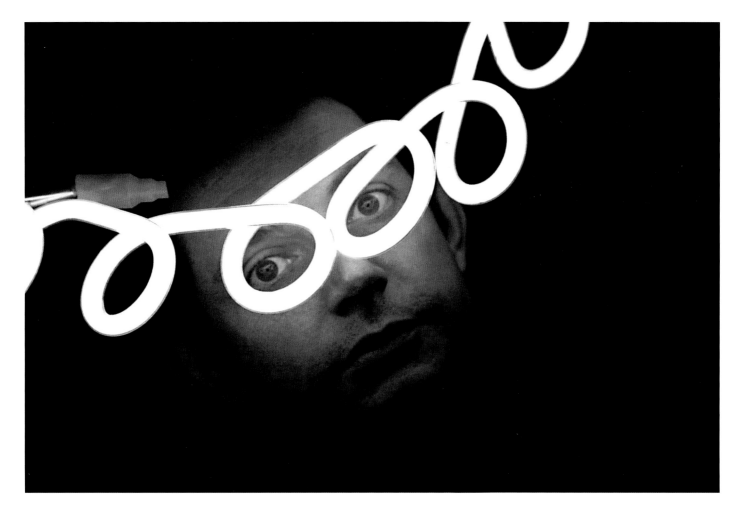

neon tubing

It's not that often that the lighting for a portrait forms an essential element in the shot—but that's what happened here. The subject is an artist who works with neon-filled lights, and Neild wanted an image that conveyed that fact in an eye-catching way. After trying out a number of ideas she noticed a curled length of neon tubing hanging from the ceiling of the gloomy workshop where she was taking the pictures. It wasn't long before she had the artist balancing on a box, peering through the circles to produce the photograph she was looking for. No other lighting was added. Metering to make sure the face was correctly exposed, she allowed the neon tube lighting to burn out, and the final print—already monochromatic—was printed in black and white.

Pauline Neild

Manchester Evening News newspaper

Press

28–105mm (at 80mm)

1/15sec at f/4

Ambient light

Taken as part of a portfolio shoot for a musician, this image was lit from a large window to the right of the camera, with a silver reflector beneath the subject. "As usual, all my digital work is captured raw and processed in Apple's Aperture software," explains Nigel Harper

- Ⓐ Nigel Harper
- Ⓑ Private portfolio
- Ⓒ Publicity
- Ⓓ 50mm (efl 75mm)
- Ⓔ 1/125sec at f/1.4
- Ⓕ Ambient light and reflector

gaz

The tilted camera angle adds impact to this simply lit yet powerful portrait.

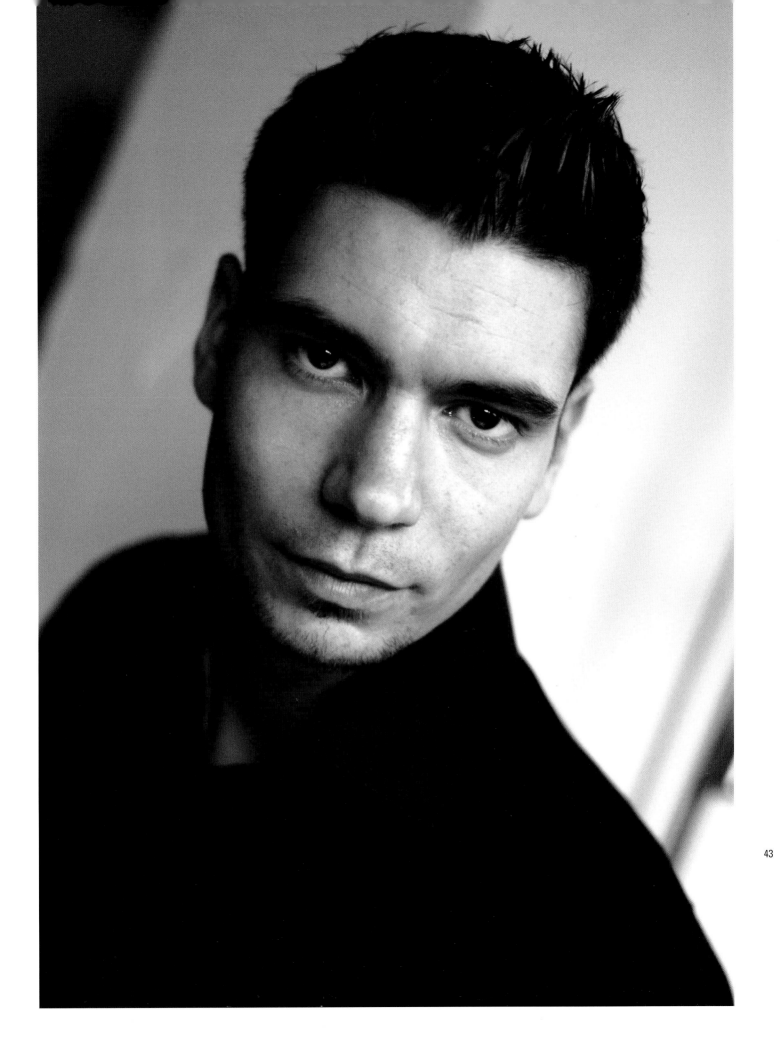

This image was taken as an exercise in using tungsten light sources. The light source in question was a simple domestic flashlight with a 4 in (10cm) diameter lens, taped over the front was a convex plastic diffuser.

"I use this light source now extensively both inside and outdoors at weddings, in low-light conditions of course," says Nigel Parker.

"The camera—a Nikon D2x fitted with a Nikon DX 17–55mm f2.8 lens—was tripod-mounted and the flashlight was held out to left of camera to create the shadows. Some daylight was coming down from a window above the stairs but the main light source was of course from the flashlight. The camera's white balance was set to tungsten for an accurate color rendition."

- Nigel Parker
- Personal project
- Various
- 17–55mm
- 1/60sec at f/2.8
- Ambient and handheld flashlight

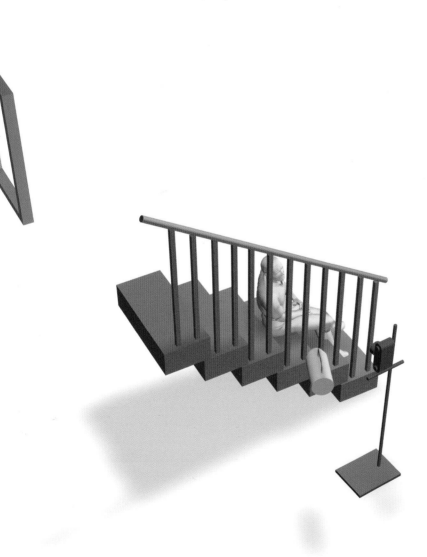

just

Stark shadows created by the flashlight and the bars in the foreground combine to create a somewhat disturbing and claustrophobic result.

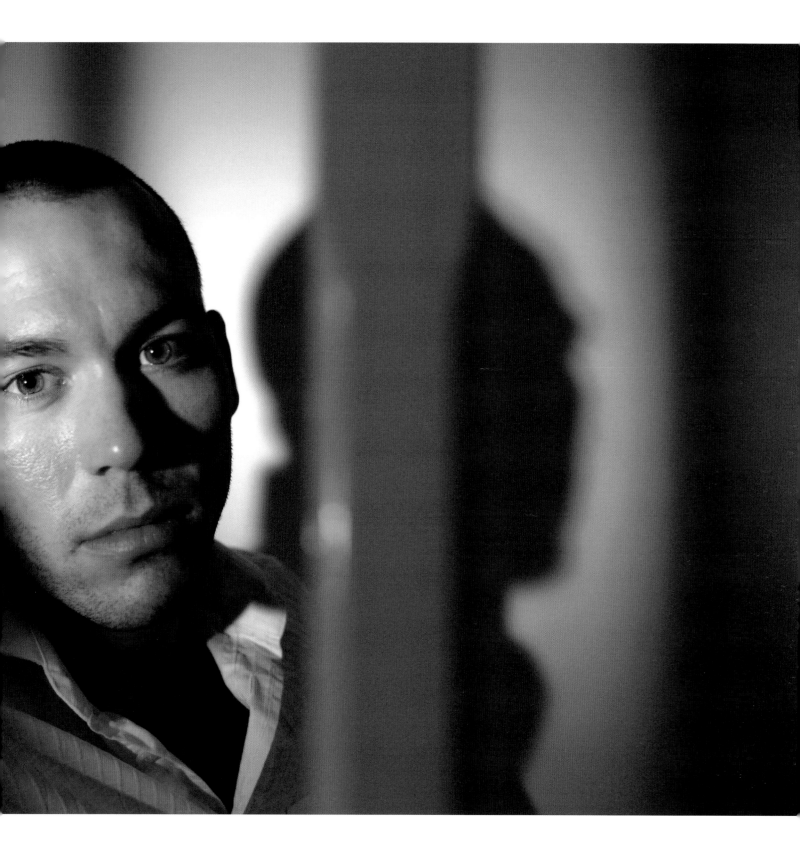

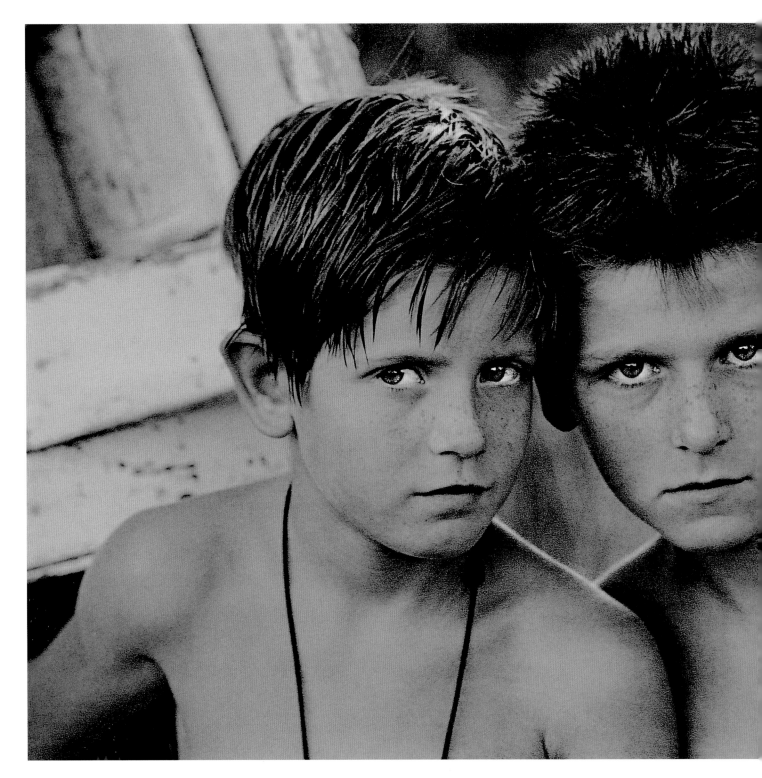

two boys

The soft lighting at the end of the day is perfect for flattering portraits.

Tamara Peel

Private commission

Family record

28–105mm zoom (at 105mm)

1/30sec at f/3.5

Ambient light

It's a truism of photography that the quality of light is more important than the quantity, but if you wanted proof you need look no farther than this picture taken toward the end of a summer's day, when the sun was low in the sky and the exposure set at just 1/30sec at the maximum aperture of f/3.5. With the sun setting behind the boys to one side, the only light directly on their faces was reflected from the sky, resulting in a flattening of the features, with only soft, subtle shadows around the eyes, nose, and mouth. The really slight rim lighting was enhanced by bleaching the lith print in the darkroom.

The boys have wet hair because they've been playing on the beach all day, and the timber behind them is an old upturned rowing boat. Photographer Tamara Peel knew exactly what she wanted and asked them to put their heads together, and as they did so they looked straight at the camera. "This was the first shot on the roll," she says, "and I knew when I pressed the shutter it was just perfect. I did lots of alternative treatments, but none were as good as this."

using handheld 35mm for kids

"I use an autofocus 35mm SLR for photographing kids because you've got to get in there quick and catch the action before it goes. With a medium-format camera you need to use a tripod, and before you know it you've lost that magical moment."

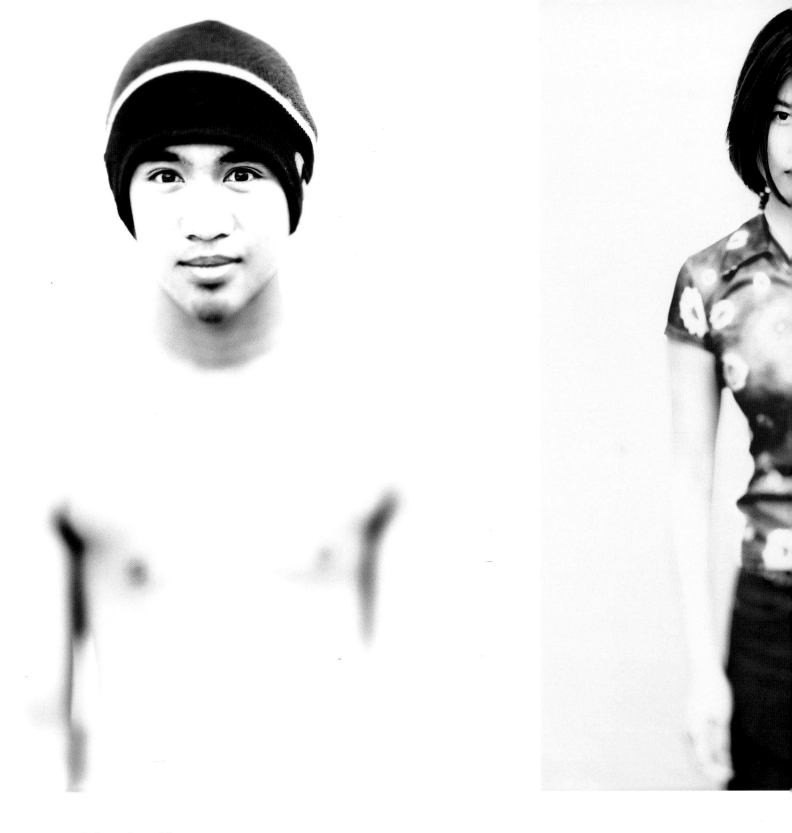

white bodies

For an alternative approach to producing a bleached-out effect, try shooting in the shade and cross-processing the film.

These portraits appear to have been digitally manipulated, but in fact the eye-catching effect is the result of cross-processing, the use of camera movements, and careful printing.

Photographer Tobias Titz met the subjects on the street and asked them if they would pose for him. When they agreed, he arranged to meet them later for a session. Planning to cross-process the transparency film in color negative chemistry, he deliberately chose a location that was low in contrast—the shadow side of a building. Because he wanted the background to burn out completely, he found somewhere suitable with a white wall. As the finished images show, the resulting frontal light has a strong "fashion" feel to it, as if a large softbox has been placed over the top of the camera.

In order to have the boy's head stand out from his body, Titz used the full potential of the view camera's movements and set the lens to the maximum aperture of f/5.6.

Tobias Titz

Personal project

Portfolio

240mm

1/30sec at f/5.6

Daylight

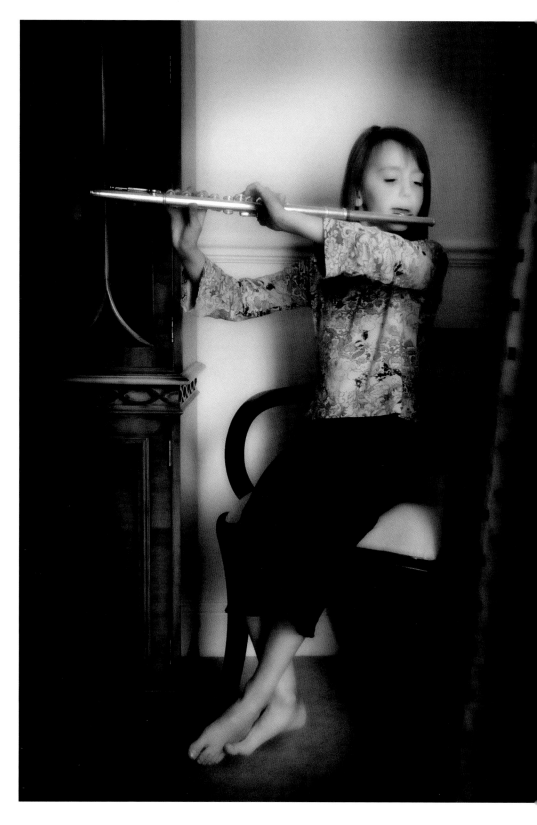

amelia plays flute

Natural lighting, the drapes, and the furniture, all help to enhance the gentle nature of this domestic scene.

It's often effective with location portraiture to include props, especially when they're relevant to the subject. The inclusion of the flute in this shoot sparked off a whole raft of photos from wacky images to extreme close-ups. However the final image shown here is simple and effective. By placing the subject in a corner of the dining room, the photographer was able to control the light by opening or closing the curtains from the window, the main light source, to the right of camera. No reflectors were used or needed. However, parts of the image were subsequently dodged or burned in postproduction to enhance the mood and to play down distracting elements.

(人) Nigel Harper

(⊙) Personal project

(◆) Various

(◉) 50mm (efl 75mm)

(◯) 1/60sec at f/1.4

(◎) Daylight

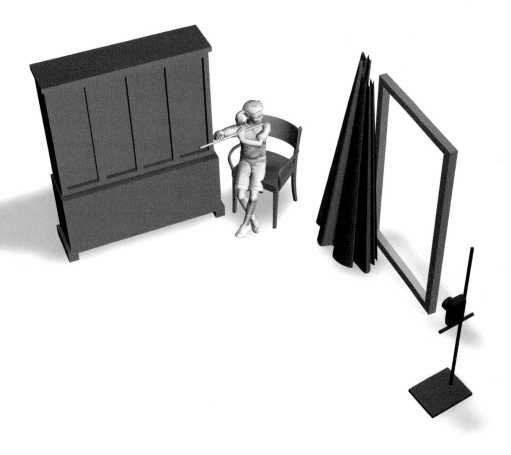

Ar schickte das Kind
fort. Als er sich
umdrehte kam ihm
die Zukunft mit
offenen Armen ent-
gegen. Zu-
gleich konnte sein
inneres Auge die Um-
risse einer Bananen-
schule.

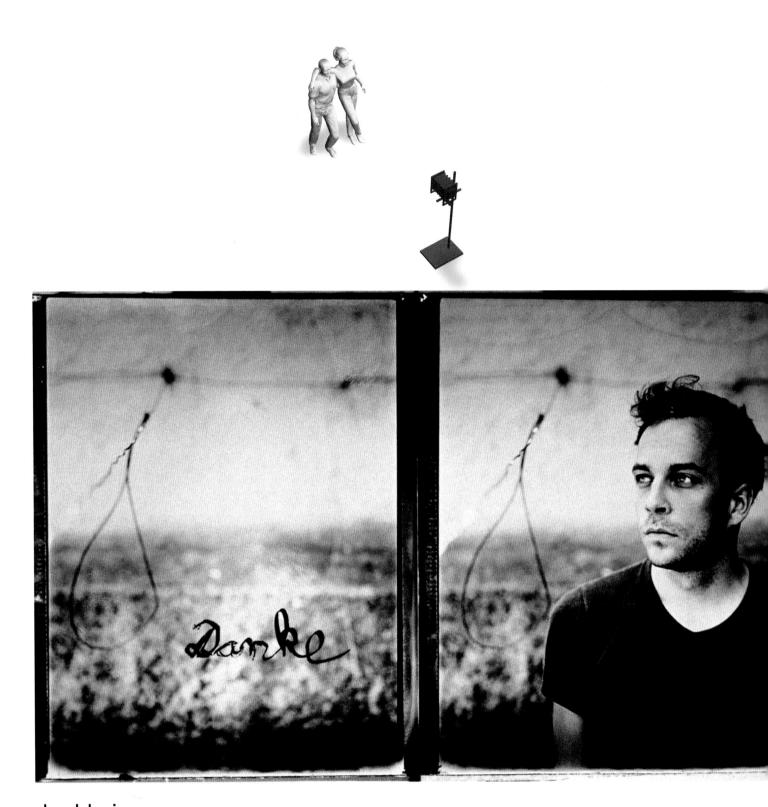

double image

Backlighting is essential for an unusual technique where the subjects are invited to contribute to the creative process.

For these striking portraits, in which the subjects are invited to become active participants in the creative process, the photographer consistently used the same techniques.

In each case, two negatives are taken on Polaroid film: the first is a portrait in the normal sense of the word, and the second is exactly the same but without the person—who is then invited to scratch something into the negative. This could be words, a drawing, or anything that reflects what they think about the photograph, and themselves, at that moment.

Because the technique requires a light background so that the "scratches" can be read clearly, Titz always searches for an outdoor daylight location in which the light is coming from behind—never from the front.

- Tobias Titz
- Personal project
- Portfolio
- 240mm
- 1/60sec at f/5.6
- Daylight

simple lighting

baby in hands

A single light placed high above the subject is perfect for low-key lighting effects.

Low-key images require considerable lighting and printing skill to be successful—but here the photographer has got it just right, with a full range of tones encompassing rich, deep shadows and clean, white highlights.

The secret is simple lighting, with just one head fired into an umbrella placed up high and slightly to the left, around 3ft (0.9m) away from the subject. A white reflector helps fill in the dark areas on the right-hand side. The background is a standard black paper roll that's 12ft (3.6m) back from the subject to prevent any light falling onto it. For a more dramatic perspective, a low camera angle was chosen.

Erwin Olaf

Personal project

Portfolio

120mm

1/500sec at f/11–16

Electronic flash

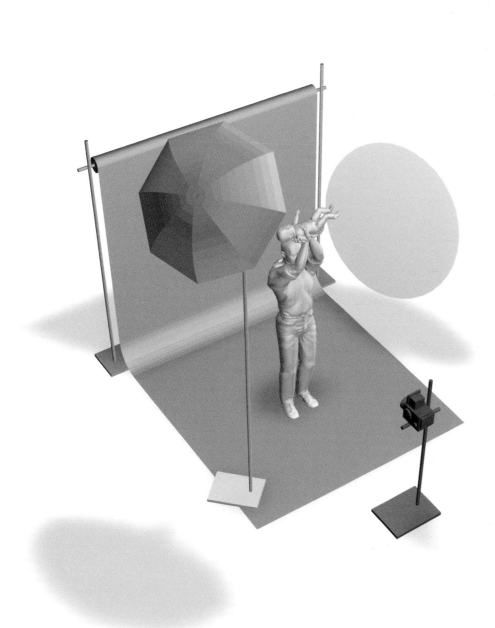

Using a low-powered burst of fill-in flash to balance the exposure with light coming in from a window is a common enough technique, but doing so in a way that produces natural, believable results takes a fair bit of skill. If there's not enough light, the effect isn't noticeable; if there's too much, the subject looks overexposed compared with the ambient light. Here the photographer has got it just right, using a snoot on a studio flash head to pick out only the subject and prevent stray light falling onto the backdrop. The blue tint was added at process stage.

Dave Willis

Private commission

Portfolio

180mm

1/15sec at f/8

Electronic flash and daylight

anakin skywalker

When using light to fill in the subject, you need to control it carefully.

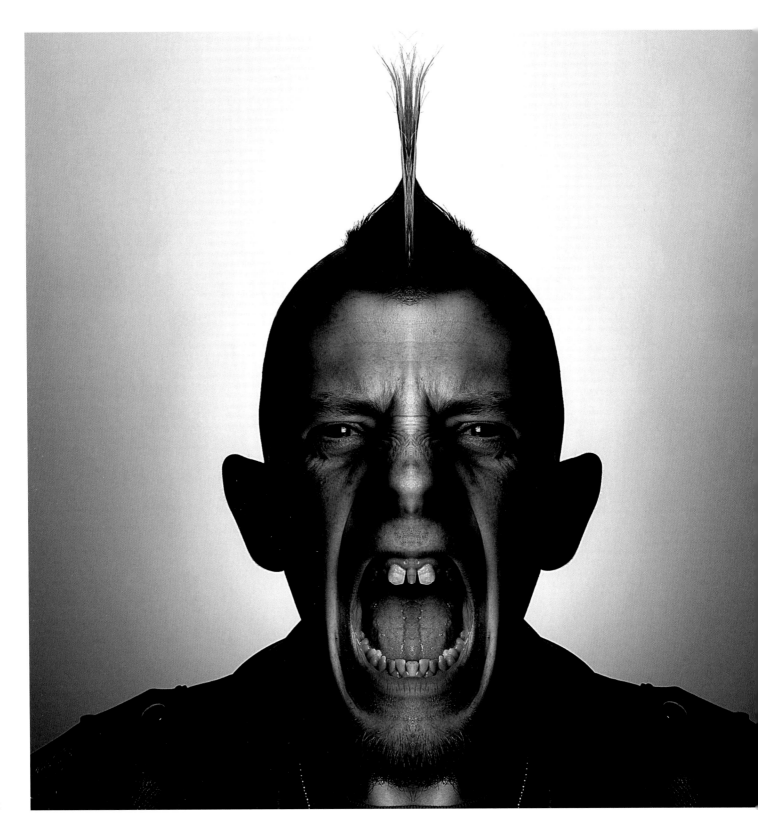

bluey

A Phase One Lightphase digital back was used to capture as much detail as possible for this striking image.

The subject had a great mohawk but Karen Parker wanted to capture something more creative than a simple, side-on view. A separate light on the backdrop was two stops overexposed and placed at floor level, and had a circular shade to create a pool of light. Large black flats helped to control any light spill. A second light diffused with a softbox was placed in front of the subject, who enthusiastically shouted on demand. The chosen image was cut in two and mirrored in Photoshop and then converted to a striking bluetone. A lot of people give this portrait a double-take, making it a real talking point in the studio.

Karen Parker

Private commission

Various

80mm

1/125sec at f/18

Electronic flash

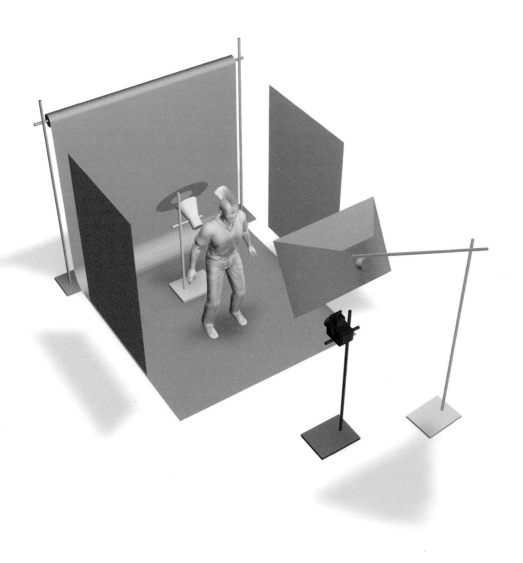

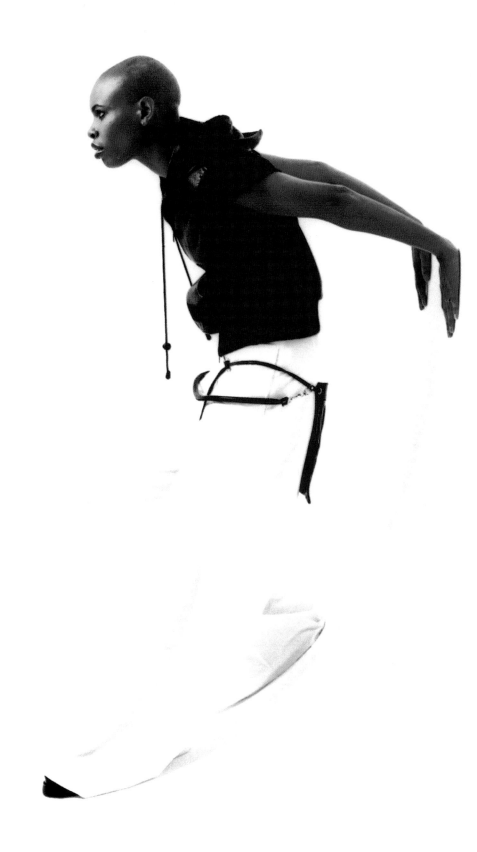

Cross-processing a slide film in color negative chemistry to bump up the contrast often means you don't need to use so many lights. For this shot of the singer Skin, only one softbox was used. She's facing the light directly, as can be seen by the large highlight on the face. The highlights on the arms are the result of light bouncing off the white ceiling and the wall she's leaning on. Her dark skin tone accents this. The shot was printed to maintain detail in the shadow areas, which meant the lighter tones burnt out, producing a punchy, high-contrast effect. Cross-processing effects can also easily be achieved using image-editing software, such as Adobe Photoshop.

Ⓐ Dave Willis

Ⓢ *Kerrang!* magazine

Ⓔ Editorial

Ⓕ 250mm

Ⓣ 1/60sec at f/8–11

Ⓛ Electronic flash

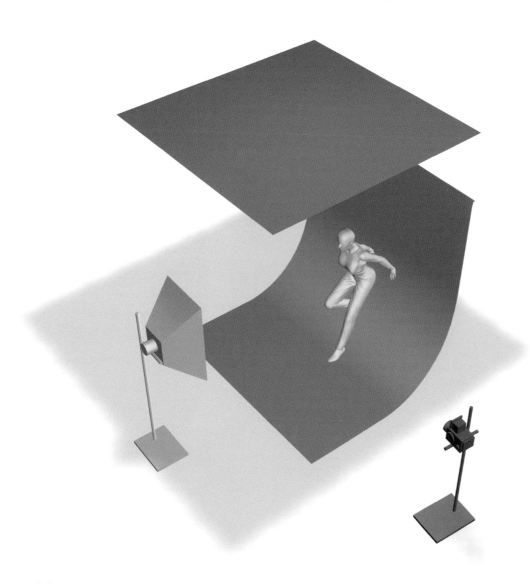

skin

One carefully positioned light is sometimes all you need.

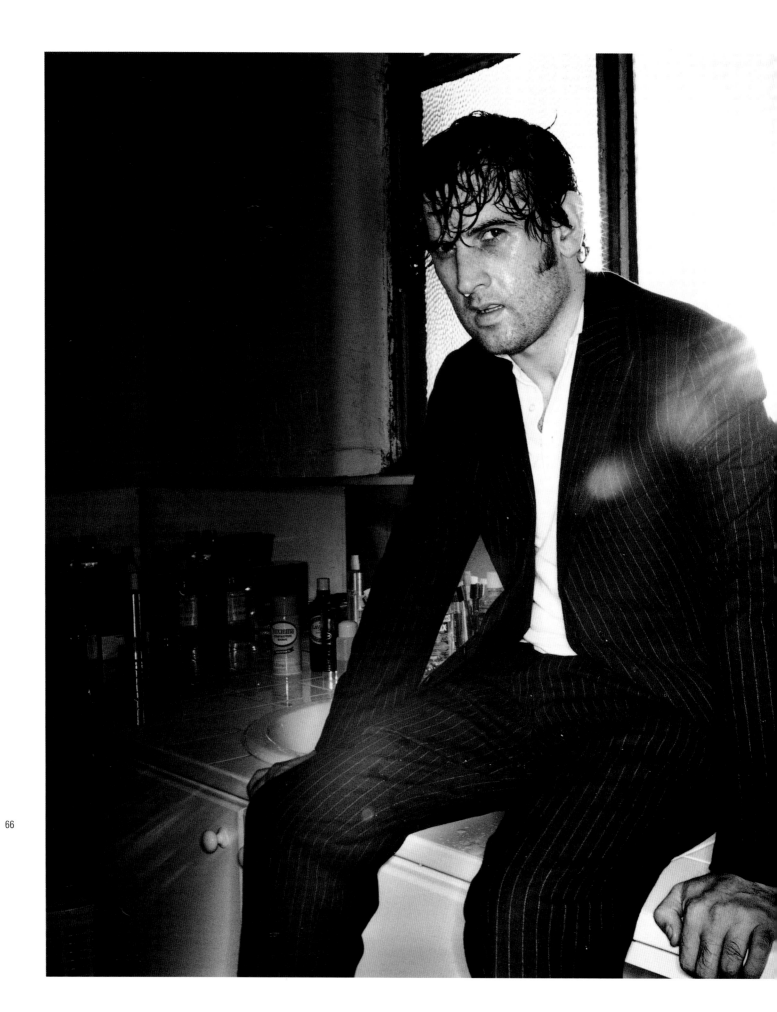

This naturalistic portrait looks almost as if it could have been a snapshot, captured casually in the middle of a party. In actuality it was a carefully constructed shot intended to create an imaginary "dramatic moment" to illustrate a feature on bathrooms—and the expression is intended to illustrate that.

"I positioned the model so there was a strong backlight from the window, and then I balanced the exposure with lighting from the front," says Hiroshi Kutomi. A ringflash was chosen as the light source because it gives a sharper, harder illumination. The stray non-image forming light present in the image was caused by shooting into the light, providing a "morning-after" atmosphere.

- Hiroshi Kutomi
- *i-D* magazine
- Editorial
- 90mm
- 1/250sec at f/22
- Electronic flash and daylight

ringflash fill-in

"Casual" compositions require careful setting up.

It's difficult to guess how this photograph was created. The image was not composited digitally—actually the model is lying in an aquarium measuring 4½ x 4½ft (1.3 x 1.3m), which is full of milk and water. A sheet of glass was placed on top of this, onto which the egg was broken. Care had to be taken to ensure the model had ventilation at this stage. For the yolk to be large enough, they had to use a goose egg. "This was a difficult shot to set up," says photographer Joachim Baldauf, "but the lighting was easy."

All that was used was one flash head fitted with a softbox, placed, as the catchlight from the yolk clearly shows, over the top and up to the right of the camera.

Joachim Baldauf

Amica magazine

Editorial

105mm

1/30sec at f/8

Electronic flash

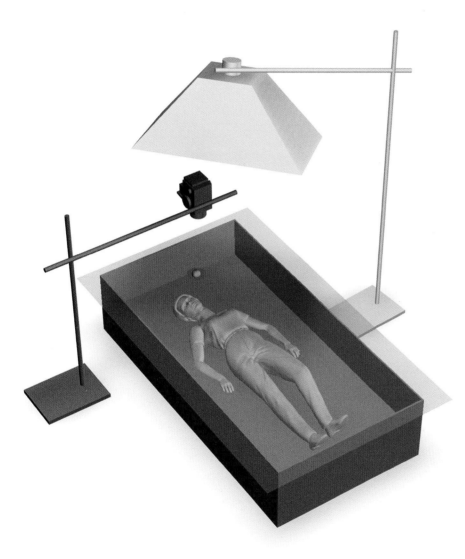

egg

Sometimes lighting is the easy part…

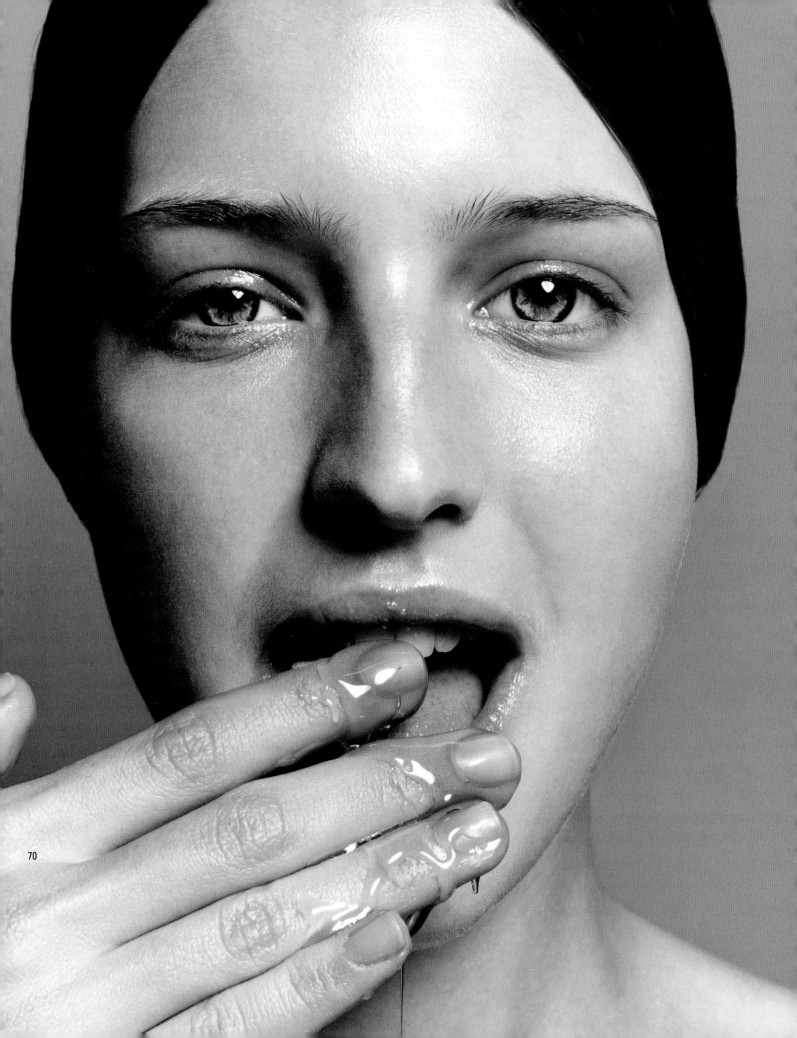

This picture was one of a series taken to illustrate the theme "Makeup you can eat," and its great strength is in its simplicity—nothing has been allowed to take your attention away from the subject.

Cropping in tight minimizes the amount of background we see—and that, in any case, has been painted virtually the same color as the honey. The hair has been tied back to reveal the face, and the straightforward one-head setup provides full illumination without heavy shadows. As can be seen from the prominent catchlight in the eyes, the light is a softbox, angled diagonally to provide a triangular-shaped light, up to the right of the photographer.

Joachim Baldauf

Amica magazine

Editorial

105mm

1/30sec at f/8

Electronic flash

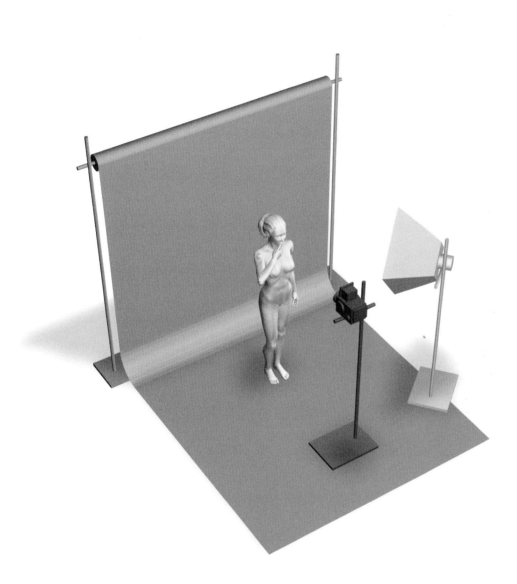

honey

A strong idea can benefit from simplicity in composition and lighting.

This portrait of film music composer John Barry, who arranged the James Bond theme, has a marvellously strong composition. "I normally set the camera up on a tripod and then leave it there," explains Mark Guthrie, "and if the person then moves a little you end up with an unconventional crop that can be more interesting. This image is pretty much as it was shot."

The picture was taken at Barry's home, and includes more of the surroundings than would normally be Guthrie's style. "I took a roll of background paper with me," he says, "but although I wasn't hugely comfortable with the ornate tapestries behind him, there wasn't anywhere convenient to put it up. Happily, it was possible to darken the background at the printing stage." There's one flashlight source on the subject, up high and to the right, fired through an umbrella.

⊛ Mark Guthrie

◒ *Time Out* magazine

◉ 75mm

◔ 1/125sec at f/16

◉ Electronic flash

72 **john barry**

Unconventional cropping can create a more dynamic composition.

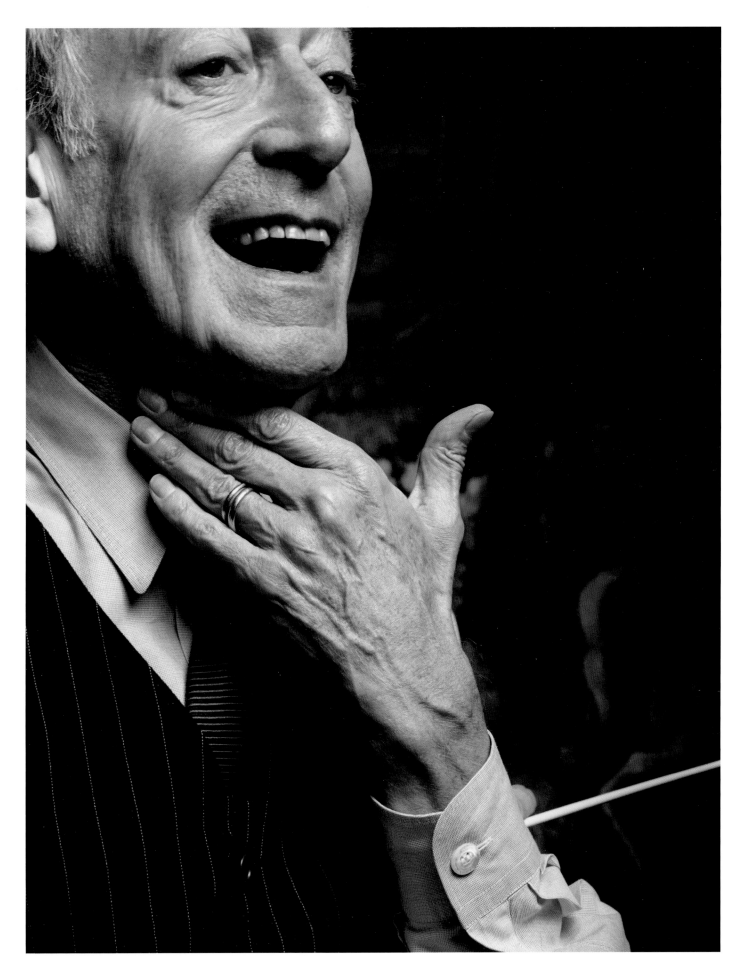

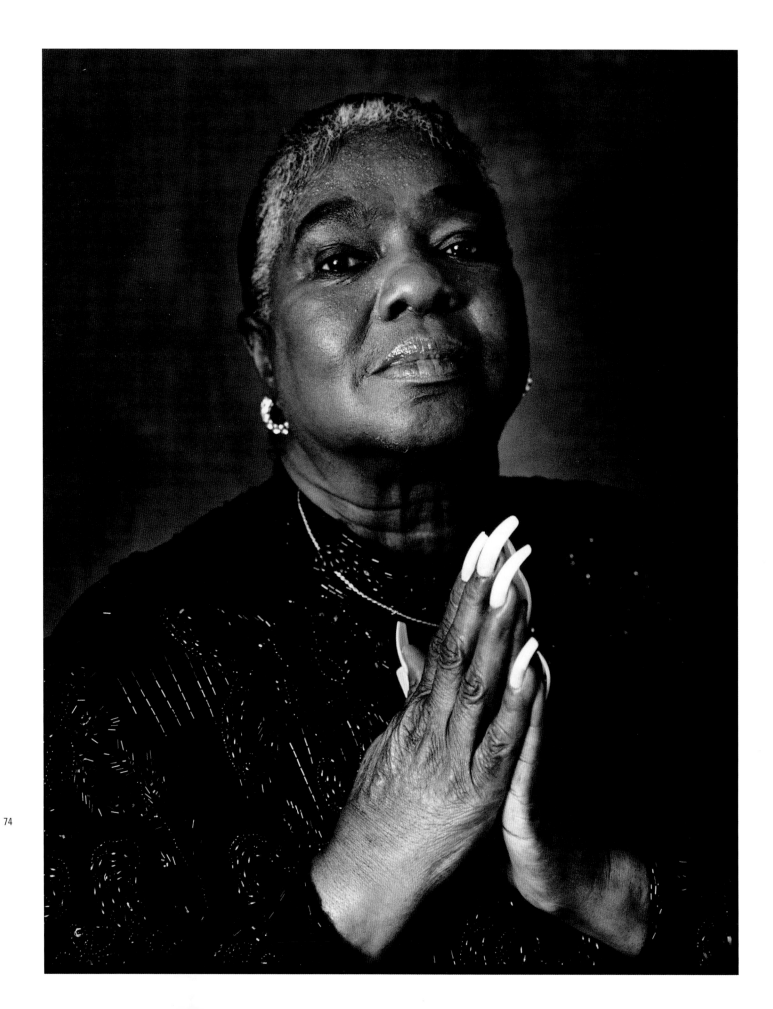

Like almost all of his black and white pictures, this shot of blues legend Linda Hopkins by Jeff Dunas was taken with just one light fired into a jumbo umbrella.

"Terence Donovan once said, 'The big guy only uses one light,' and I always thought he had a point," says Dunas. "There's a lot to be said for simplicity. Pictures taken using lots of lights can look contrived, and they date quickly. With one light source I can still create a wide range of effects by the way I position the subject, camera, and light in relation to each other."

"This picture was taken in a small makeup room, with the umbrella a few feet behind me to the left of the camera—you don't want it close to the lens, because then the lighting is flat. Here, it's not too contrasty. But if I take one step to the right, and get the subject to look at me, then it gets a whole lot punchier."

"Using one light is also a matter of not taking too much of the subject's time. I mainly shoot famous people, and they don't take kindly to sitting around while you take endless Polaroids to check the lighting. They're not conscious of these technical kinds of things. Nor should they be. I'm not constantly fiddling with my kit, that's the sign of an amateur. A professional has to commit themselves to the subject, and spend his time with them. Everything else is a distraction."

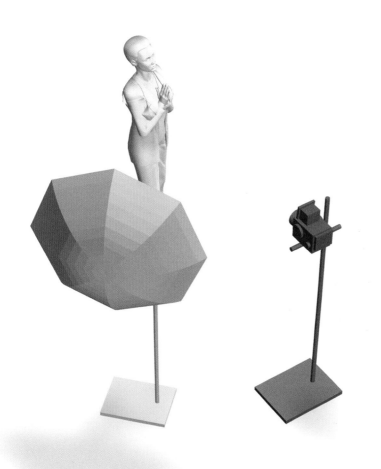

Jeff Dunas

Personal project

State of the Blues exhibition

140mm

1/400sec at f/11

Electronic flash

state of the blues

Using a jumbo umbrella gives lots of lighting control.

lighting the background

"Mostly I use the same light for the background, and depending upon how light or dark I want it to be, and/or the person's skin color, I'll just simply put the subject closer to or farther away from the background. It's as simple as that."

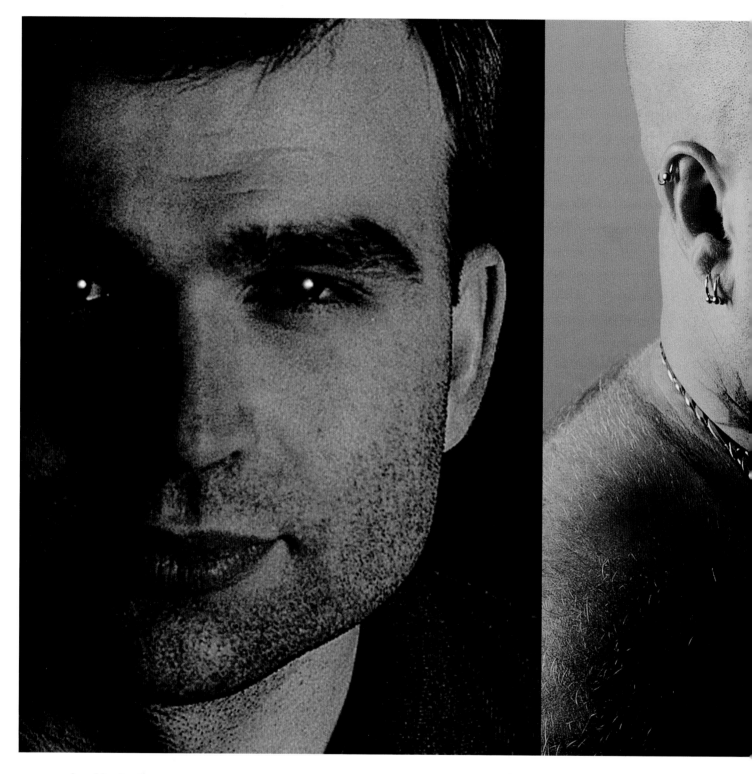

moody lighting

When using just one light, small alterations in its position can make a big difference to the effect.

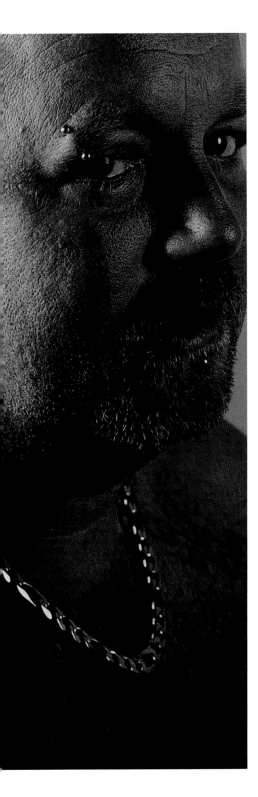

Both of these pictures were taken using just one softbox—but it's where it's placed that makes all the difference. The farther you take it around to the side, the moodier and more dramatic the result.

For this shot on the far left, the photographer placed the light at right angles to the camera, so only one side of the face was illuminated—throwing the opposite side into complete darkness, and bringing out the texture of the stubble. "I knew from the shape of his face that he would appear really moody if shot in this way," says Karen Parker, "and although I also did a series with the light at 45 degrees, they didn't work anywhere near as well."

For the tattooed man, the light has been brought a little closer to the camera—although it's still farther round and slightly higher than usual. Doing so helps reveal the contours of his physique while ensuring the tattoos are not overlit.

Sepia is considered old-fashioned, but using it for a modern shot can give an "authentic" and powerful feel. Here, it helps to bring all the elements of the subject's body enhancements together.

In both cases the framing is unconventional, with tight, off-center cropping. Parker believes in breaking the rules to produce images that are more eye-catching.

- Karen Parker
- Personal project
- Portfolio
- 110mm
- 1/60sec at f/8
- Electronic flash

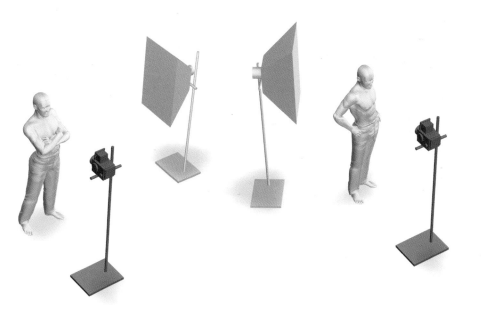

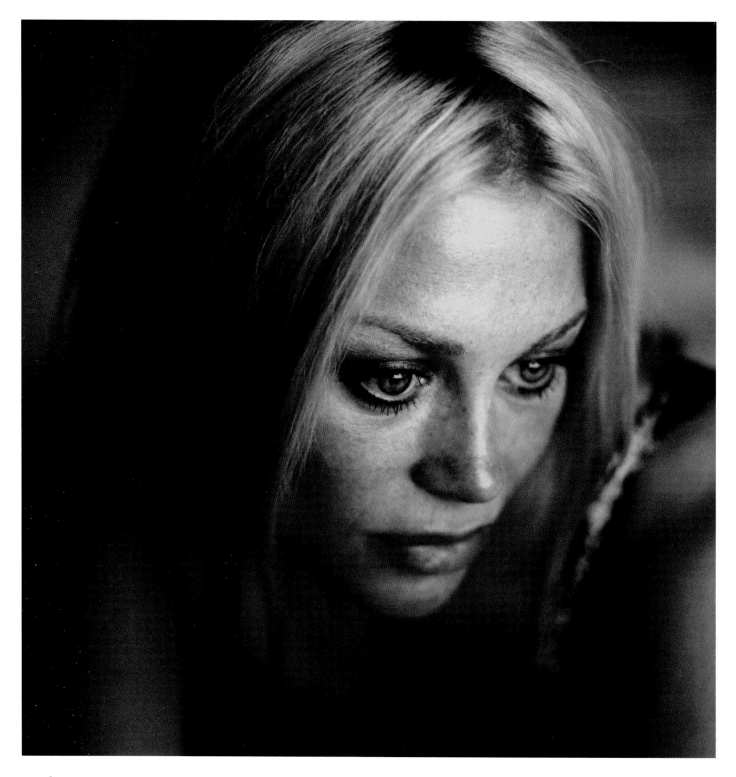

colette page

Try using just the modeling lights for a more relaxed mood in the studio.

The pop of a flash going off every few seconds can be distracting for subjects and can interrupt the mood of a session. One alternative is to employ studio lighting but to use only the modeling lights—which is what the photographer did here.

One studio flash head was diffused by a softbox and placed over to the right and slightly above head height—giving the classic effect of light coming in through a large window. Using just the modeling lights, however, means there's a lot less light to work with, and here, with an ISO 400 film loaded, the best that could be achieved was 1/15sec at f/4. The limited depth of field, though, has been put to excellent use, bringing a sense of intimacy to the shot. The tonal warmth produced by the tungsten lights was filtered out at the printing stage.

Matt Moss

Personal project

Portfolio

110mm

1/15sec at f/4

Modeling light

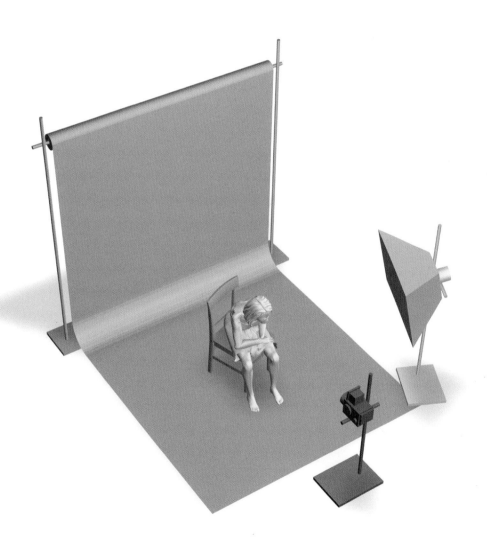

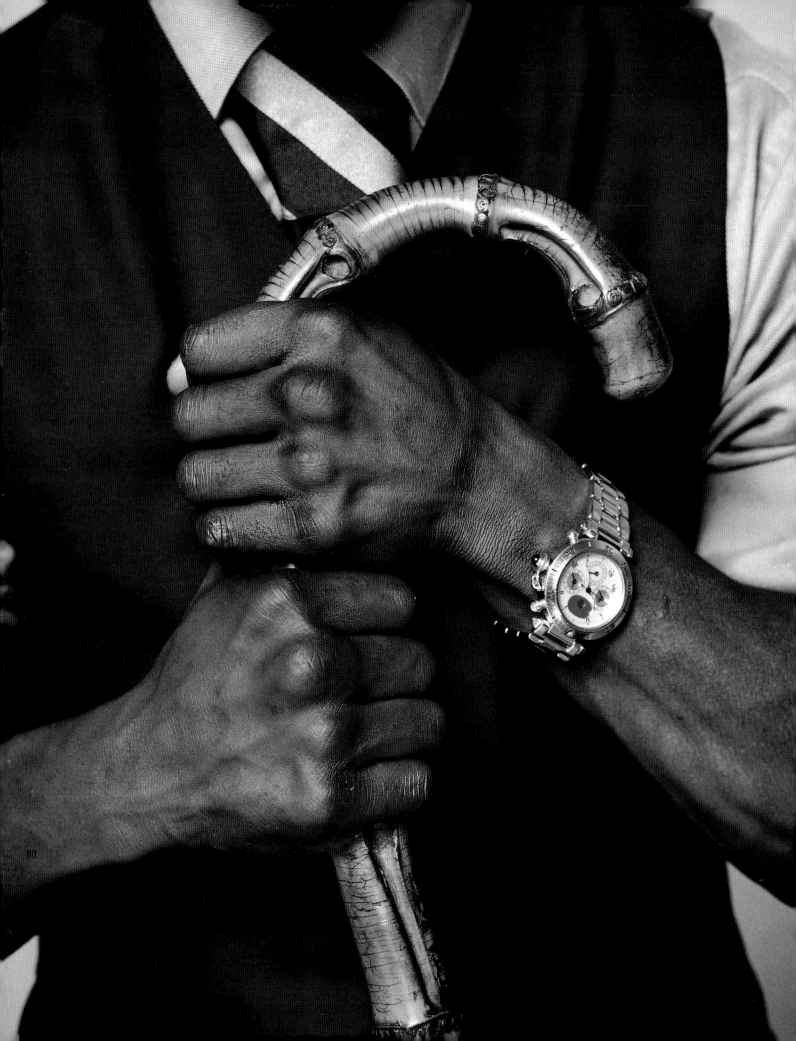

"I like to bring out something of the character in the people that I photograph," says Karim Ramzi, "and that means paying attention to more than the face. With Chris Eubank, it was the extravagant aspect of his personality that interested me, and of course—since he was a boxer—his hands."

All of the items in this wonderful close-up belonged to Eubank, and the composition is as much a beautifully arranged still-life as it is a portrait. Contributing to that is the simplicity of the lighting—just a small softbox over the camera, with a reflector below to provide fill-in.

- Karim Ramzi
- Personal project
- Portfolio
- 150mm
- 1/500sec at f/11
- Electronic flash

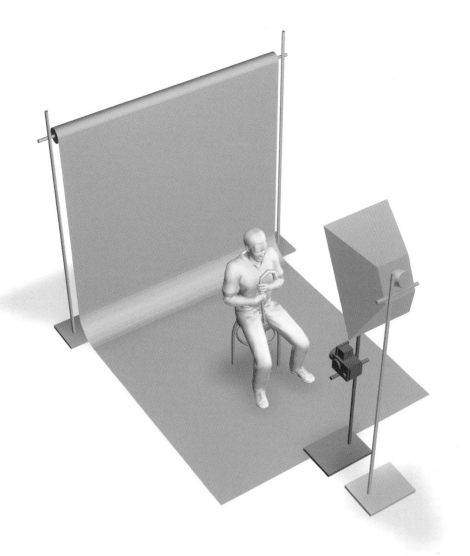

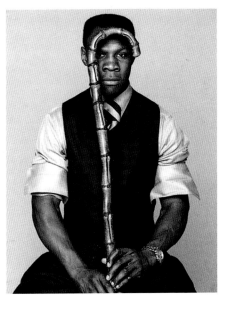

eubank's hands

If you're looking to sum up the character of your subject, use every means at your disposal.

softbox size

"Although I have tons of lighting in-studio, I like to keep things as simple as possible, and use just one light fitted with a softbox for most of my photography," says Ramzi. "My favorite is relatively small, just 3⅔ x 2⅓ft (1 x 0.7m). It gives a rather contrasty light that tends to bring out the features of the subject and gives texture to the face. I also have a large softbox, but I rarely use it. When I travel I take just two lights, one to use and the other as backup."

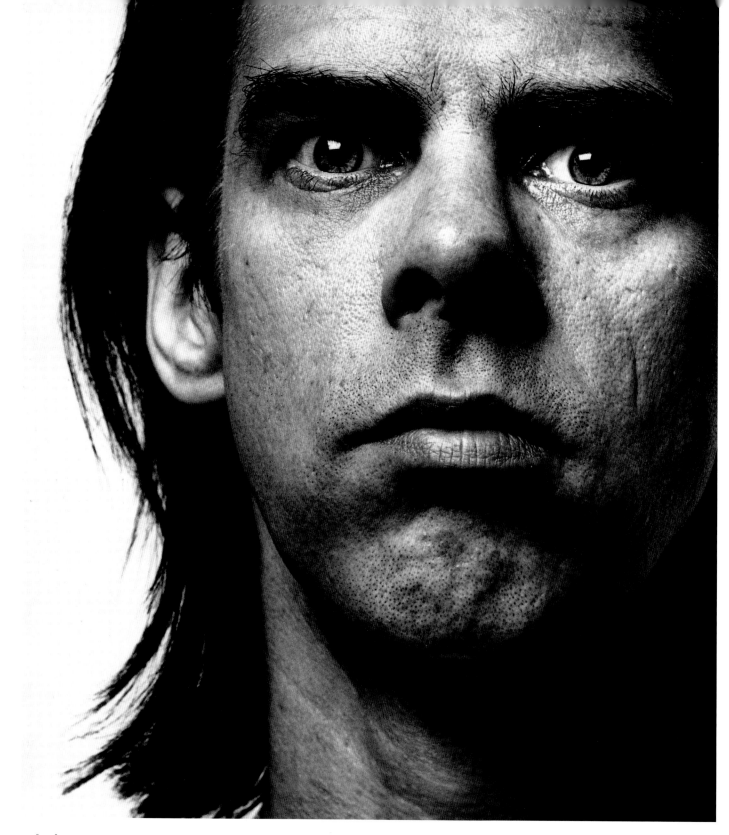

nick cave

Tight cropping, frontal lighting, and a direct expression combine to produce a compelling portrait.

They say the eyes are the window to the soul, and this picture shows how powerful they can be when photographed well. By going in close and lighting the subject simply, an arresting expression has been captured.

Just one softbox was used, positioned to the left of the photographer and raised slightly above head height. "Nick Cave doesn't like being photographed at the best of times," says Guthrie, "and for the first roll of film there was a bit of a stare-out." With the tight crop and the use of a medium aperture the depth of field was extremely limited—with the tip of the nose and the ears ending up out of focus. The use of the slow and fine-grained black and white film Pan F, together with the 6 x 7cm format, means that every detail of the complexion is recorded.

Mark Guthrie

Time Out magazine

Editorial

90mm

1/125sec at f/8

Electronic flash

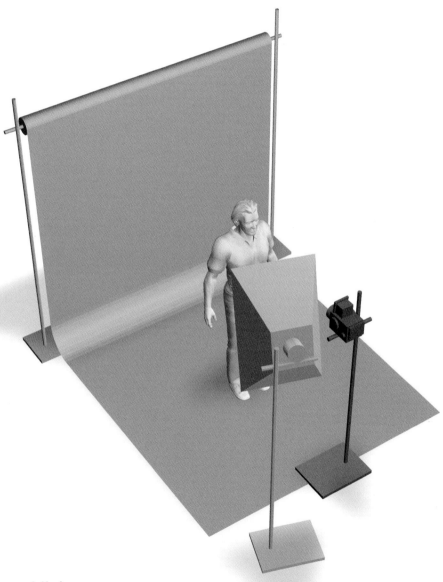

catchlights

In the majority of portraits the eyes are the most important element. If the eyes lack sparkle, the picture can look flat and fail to engage the viewer. One of the easiest ways of bringing a portrait to life is to make sure there is a point of light or "catchlight" in the eyes—and this is easily achieved no matter what the lighting arrangement. Simply place a point source of light or a reflector close to the lens, and you'll automatically see it reflected in the eyes.

84

A portrait is a likeness of an individual, and doesn't necessarily have to show the face. If the subject is famous for some other part of him or her, then it makes a lot of sense to show that instead.

"I was taking some pictures of the athlete Linford Christie," says Guthrie, "and because he's known for his legs I suggested at the end of the session that it would be interesting to photograph them as well. He was wary at first, but finally agreed."

Illumination came from a studio flash head fitted with a softbox that had a sheet of perspex over the front, producing a warm and diffused light. The light to the left of the photographer had been positioned to illuminate the face and upper body, and was simply angled down when the leg pictures were taken. The relatively high position helps reveal the well-developed muscle definition. A simple black paper backdrop helps the subject stand out, and leaving the hands in helps to frame the shot.

Mark Guthrie

Untold magazine

110mm

1/125sec at f/11

Electronic flash

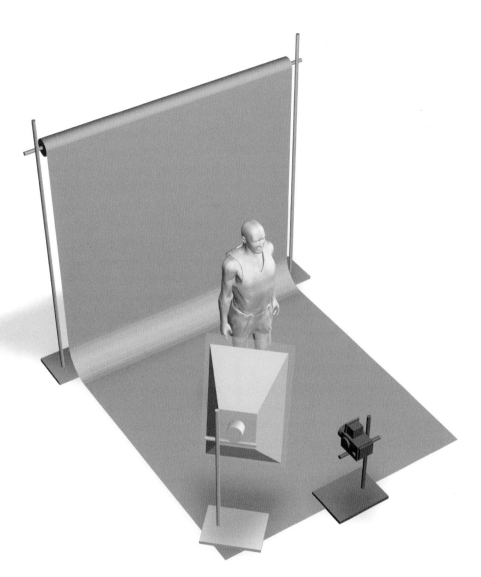

linford christie's legs

There's more to photographing people than their faces.

While on-camera flash is far from ideal for many subjects, it can be used to give an exciting "reportage" or "press" effect in certain situations. It is also ideal when you have to work quickly and don't have time to set up further lighting. For this grab shot, a powerful gun fitted on a bracket to the left of the camera produces characteristic frontal lighting with a shadow behind.

To include some of the ambient light and to produce a little movement, a shutter speed of 1/4sec was used, rather than a faster flash sychronization speed, which would have been an option.

- Matt Moss
- Personal project
- Portfolio
- 50mm
- 1/4sec at f/11
- Electronic flash

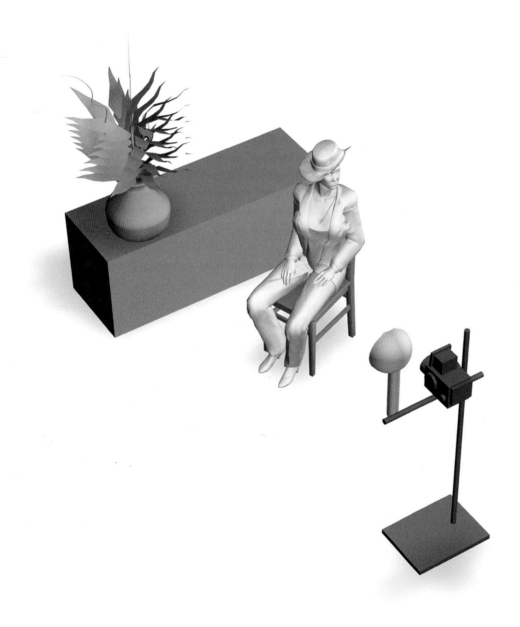

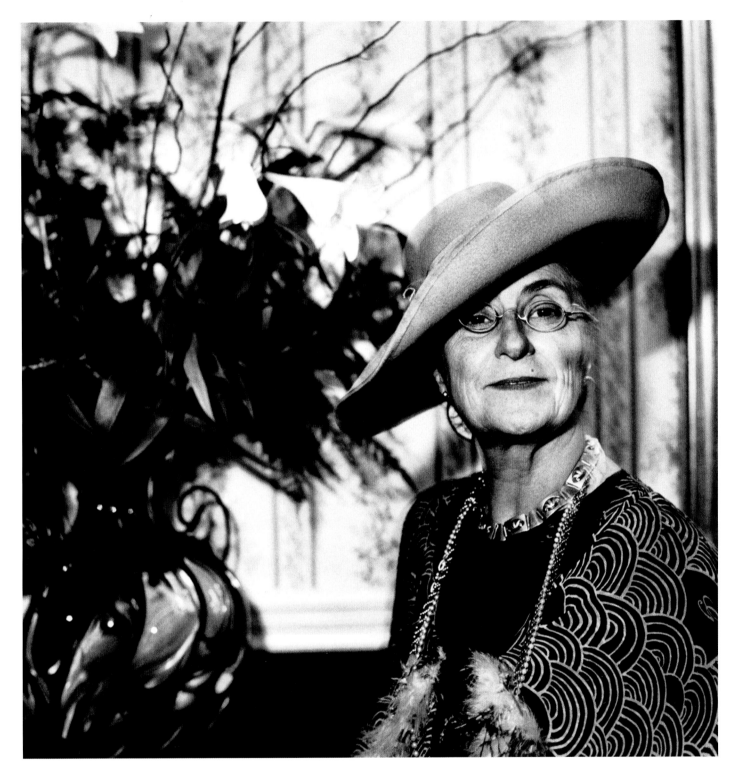

jessica destee

On-camera flash needs to be used with restraint, but it can sometimes be just the right approach.

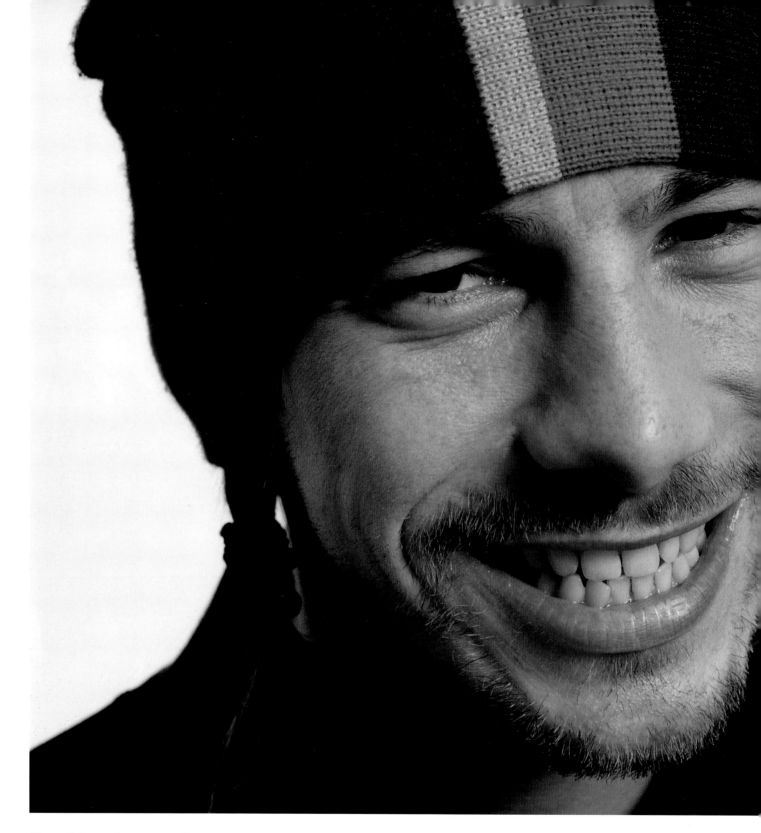

jk of jamiroquai

How to get something unique from a well-photographed subject.

Mark Guthrie

Untold magazine

90mm

1/125sec at f/8

Electronic flash

Producing unique images of a musician promoting an album or tour can be extremely challenging, because you know they're going to be seeing other photographers wearing the same clothes. This was a particular concern for Mark Guthrie when producing a series of shots of JK from the group Jamiroquai. Known as "the cat with the hat," JK's always seen wearing one—and he turned up for the session in a distinctive striped design.

"We knew he'd been doing other press that day," says Guthrie, "and we didn't want our shots to look the same, so we tried to persuade him to take it off, but he wouldn't. So we dashed downstairs to the bar of the hotel where we were taking the pictures and got a cigar, which he was happy to use as a prop in some of the shots. However, the best shot of the whole session—which was used as a double-page bleed—was taken when he turned round suddenly, took a drag of the cigar, dropped his hands, and smiled."

The result was this apparently relaxed and natural image, which belies the skill that went into creating it. The light came from a shoot-through brolly just above eye level, and because the session was held in a small room with a lot of white walls, Guthrie wasn't too worried about where his subject was in relation to the light. "As I was taking the pictures he was moving up to 4½ft (1.3m) either side of where the light was initially set, but because of the white walls it didn't really matter exactly where he was when I fired the shutter release." In fact, as the shadows indicate, the light was slightly to the right of the photographer. Although there are no catchlights in the eyes, it's a tremendous shot considering the circumstances under which it was taken.

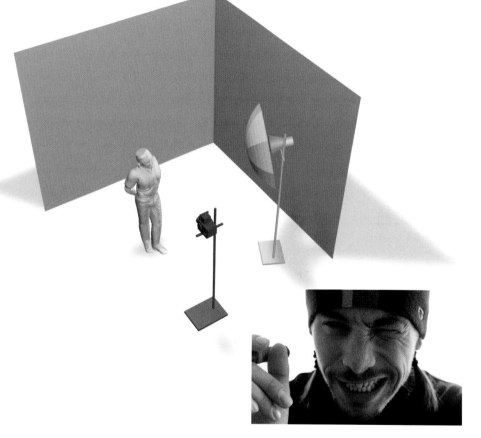

candid camera

89

This picture was taken candidly against the light using handheld 35mm equipment. Although technically not a match for the larger image—in that the contrast and definition are lower, and there is more than a little flare—the spontaneous expression works really well.

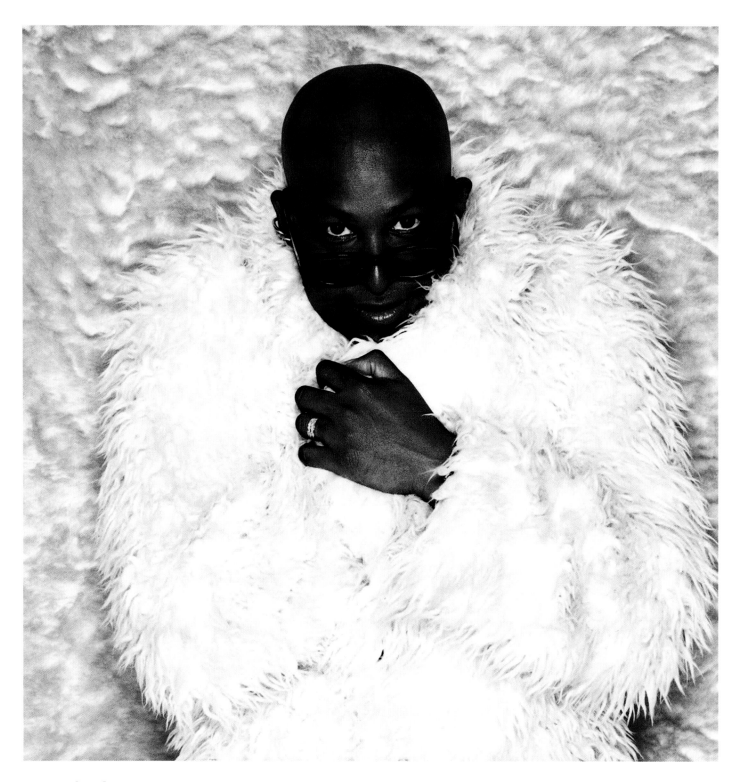

man in fur coat

If you have a large softbox, you can improvize the effect of a ringflash.

The effect you get from a specially designed ringflash can be extremely appealing, but it's hard to justify the significant investment if you're only likely to use it occasionally. However, if you've got a large softbox it's possible to improvize the effect by standing directly in front of it to take the photograph—and that's what the photographer did here. The result is a horseshoe-shaped light source that illuminates the subject directly from the front, creating the characteristic shadow all around.

Standing a 6 x 4ft (1.8 x 1.2m) polystyrene board each side of the subject increases the softening effect by preventing the shadows from becoming too dark.

Dave Willis

Private commission

Publicity shot

180mm

1/60sec at f/11

Electronic flash

background story

Rather than keep using the same old backgrounds, try being more imaginative. Here the fluffy foam backdrop, complementing the subject and his flamboyant coat perfectly, was sourced from a toy-packaging company.

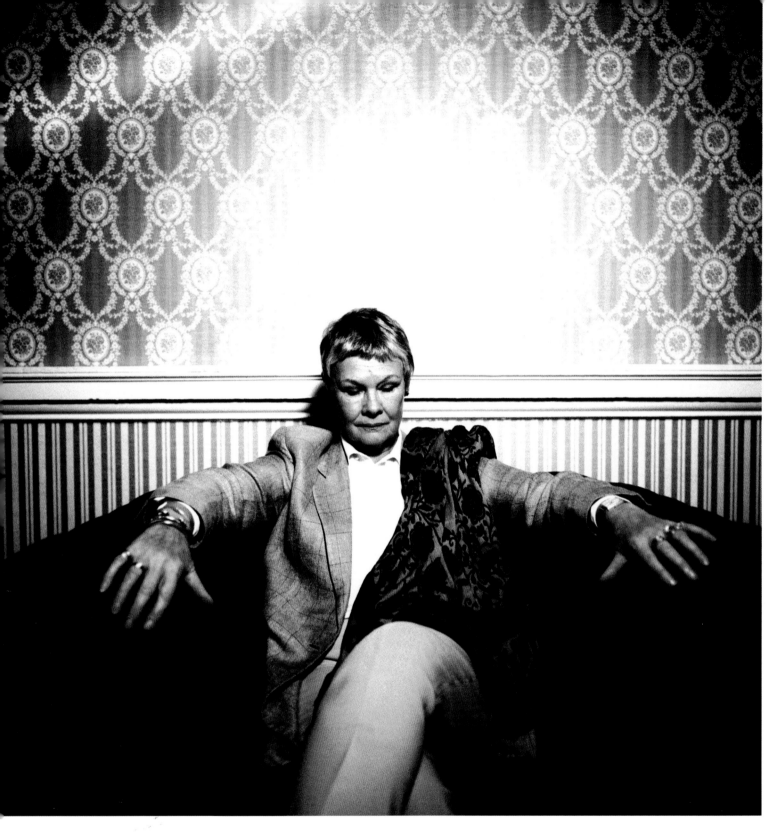

judi dench

A single tungsten head is a simple and effective solution when you don't have much time with subjects.

"I prefer to use as little equipment as possible," says Matt Moss, "because with celebrities you often don't have very long, and there's not much time for setting up."

Here Moss had the chance of just a handful of shots, and so a single tungsten light source fitted with a fresnel lens and barn doors was ideal. The light was positioned just to the right of the camera and slightly above. The light was focused onto the wall above actress Judi Dench, and the film was cross-processed. The printing technique increased the contrast, and meant the area above the head has burnt out in an interesting way. (The line of light running diagonally across the top-left-hand corner was unintentional—having bled through a gap in the barn doors). Using a continuous light source without a filter and then cross-processing inevitably leads to distorted colors.

A wide-angle lens was employed at close to maximum aperture, and this opened up the perspective of the rather small room and gave a shutter speed that allowed the camera to be handheld.

- Matt Moss
- Personal project
- Portfolio
- 50mm
- 1/30sec at f/5.6
- Tungsten

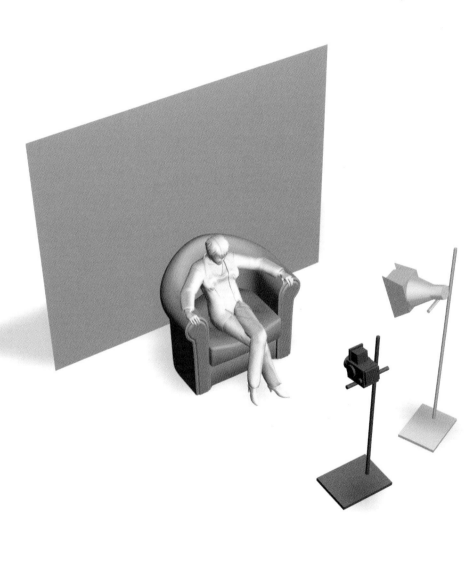

"This was one of a set of individual portraits for the band Lupa; it's difficult to get shots of band members that aren't totally off-the-wall, contrived, or a bit of a cliché," explains Karen Parker. "I was given a brief to get creative and decided that interesting facial expressions were key. The background was a piece of cotton that provided a little texture and it was placed behind the subject so that it was underlit. Lighting was kept simple with one head, and I used a triflector under the subject as I wanted a clean shot without any shadows. The color was slightly enhanced during postproduction and contrast lifted. The resulting image was strong and could also be used as a halfshot inside a CD case or on posters."

Karen Parker

Private commission

Publicity shot

80mm

1/125sec at f/11

Electronic flash

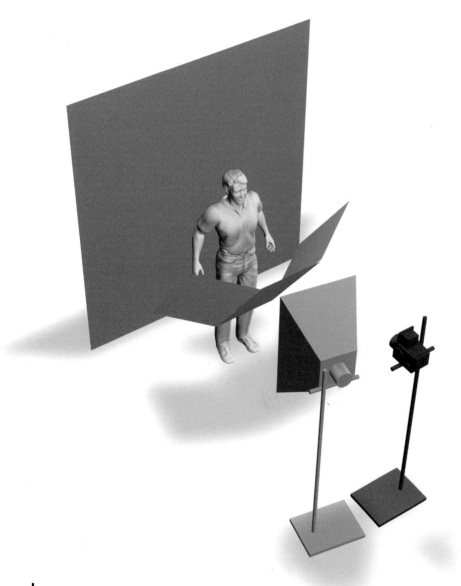

94 lupa

Simple direct lighting and a quirky facial expression were all that were needed for this photo of a musician.

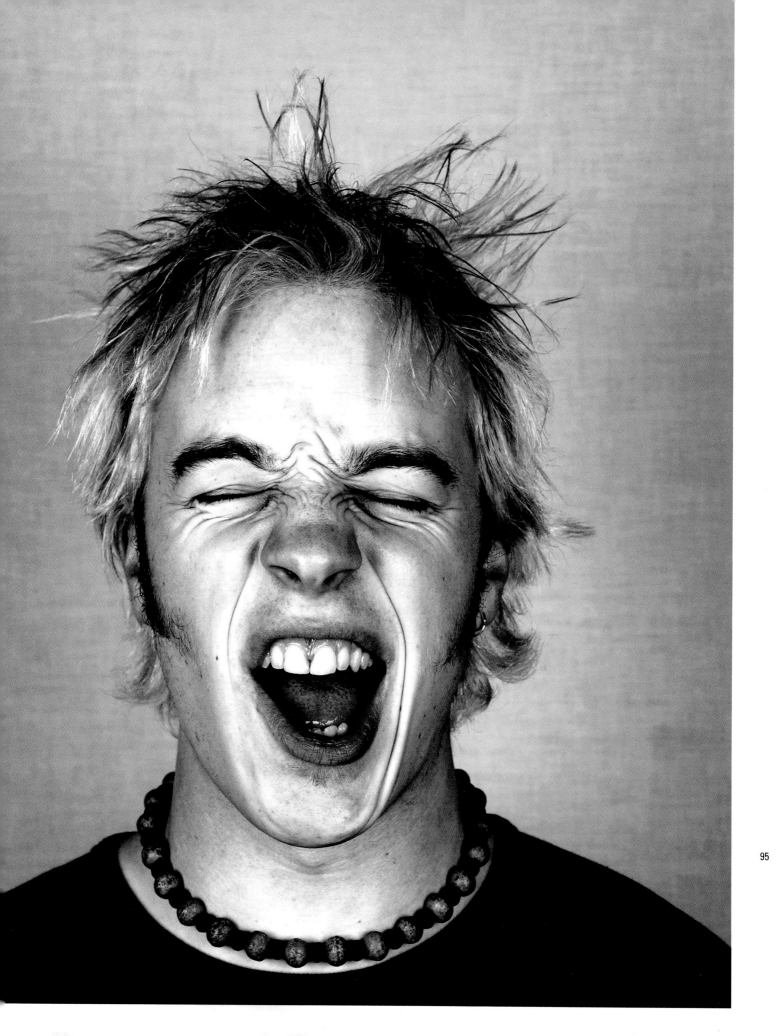

the airplane designer

Mixing flash with fluorescent helps the subject stand out from the background.

Normally you'd do all that you can to avoid having things growing out of your subject's head, but in this case the photographer decided to break the rules and deliberately composed the shot in this way. The subject was an airplane designer, so a wind tunnel was the perfect location. The lighting, though, was far from ideal—it was entirely fluorescent and certain to result in an unpleasant green cast. Fortunately, Paul Wenham-Clarke was able to get cables in, and set up a single softbox to illuminate the subject—leaving the lights behind him on and using a long shutter speed to balance the exposure.

Regarding the spectacles, Wenham-Clarke comments, "I place the light reasonably high up and get the subject to drop their chin so they're not looking at the light. Luckily modern glasses, with their anti-reflective coatings, are easier to work with; often you just need to get the subject to turn their head a little."

- ⊛ Paul Wenham-Clarke
- ⊜ British Aerospace Systems
- ◉ Graduate recruitment brochure
- ◉ 50mm
- ◷ 1/2sec at f/8
- ◉ Electronic flash and fluorescent light

using a wide-angle lens

97

"I don't like portraits that look flat, which is why I often use a wide-angle lens. It allows you to incorporate a lot of background, and it exaggerates the perspective. So long as you don't get too close to the subject, there's no unacceptable distortion."

This cleverly composed image for the same company continues the theme. Lighting is provided by a portable flashgun held as close as possible to the subject by an assistant to avoid the foreground being too bright. The shot was composed to create a near-silhouette of the plane, and the sky was underexposed to give it a dramatic and moody atmosphere.

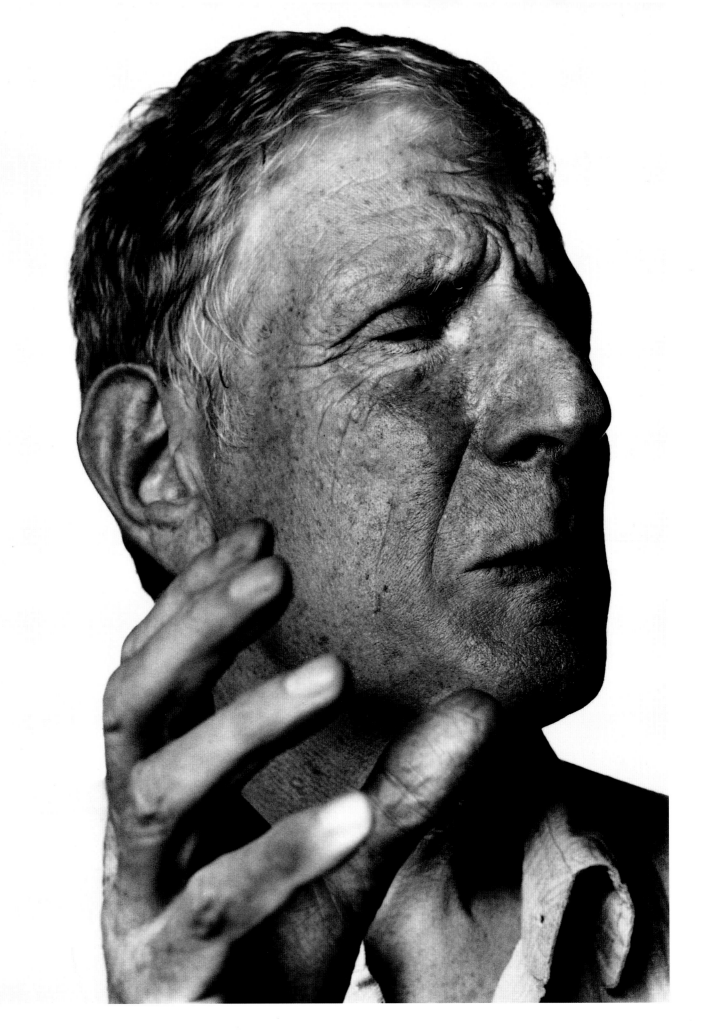

This photograph has a wonderfully sculptural quality, with the modeled, out-of-focus hands standing out from the crisp, contrasty face, and the face itself projected forward from the clean white background.

The picture was taken during a half-hour break in a theater workshop, and there was sufficient time to put up a white paper backdrop and light it separately. The head and stand are blocked by the subject—English playwright Jonathan Miller—who is lit by just one softbox that's slightly to the left. Although initially restrained, Miller became more animated during his conversation with the photographer, and this is one of several superb images captured during the session.

At the printing stage the right shoulder was taken out, so as to strengthen the line of the hands, and a hard grade of paper was chosen to produce a punchy finished print.

Mark Guthrie

Time Out magazine

90mm

1/125sec at f/22

Electronic flash

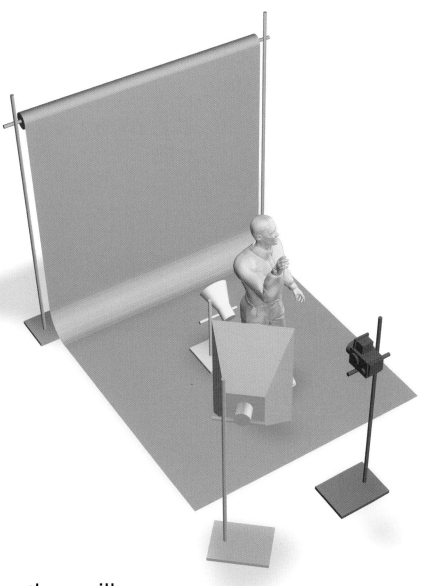

jonathan miller

Bring a three-dimensional quality to a portrait by using an out-of-focus foreground.

using one light

"Because of the circumstances under which I often work, I've learned how to get good results using the minimum of lights. Most of the time I rely on just one, and the most I ever use is two. What I like to do is go in close and get as much animation out of the person as possible. I don't have time to go for any great depth in terms of capturing their personality or character—I just aim for something lively."

It's amazing how often the first photograph taken during a session proves to be the best—as this picture of singer Marcella Detroit shows. It was a Polaroid, taken on Type 55 pos/neg film, prior to shooting on roll film. However, it proved to be the best of the bunch and was used for a variety of purposes, including a CD cover.

The lighting could not have been more simple. A single softbox was placed on the right of the camera. This was supplemented by two 6 x 4ft (1.8 x 1.2m) poly boards on the left to bounce light back in, evening out the tones. The image was then printed on contrasty paper and the face, lips, and eyes colored in by hand.

- Fin Costello
- *Observer* newspaper
- Editorial
- 80mm
- 1/250sec at f/5.6
- One studio head and reflectors

marcella detroit

Flooding the subject and background with soft light gives a light, airy feel to the picture.

Karen Parker explains: "Tricia Hignett sells beautiful jewelry and her publicity image was an opportunity to get creative. A single light setup can be quite dramatic but sometimes harsh, so this was partly counteracted by placing a triflector vertically to her side. A black roll background set far behind created a dense background out of which the subject could appear. The original idea was to convert to grayscale, which increased the effect of the pearls but while retouching we started to experiment with hand-coloring the jewelry and the result both highlighted the products and created something extra special."

(✶) Karen Parker

(◔) Private commission

(◉) Publicity shot

(◎) 80mm

(🕐) 1/125sec @ f/8

(💡) Electronic flash

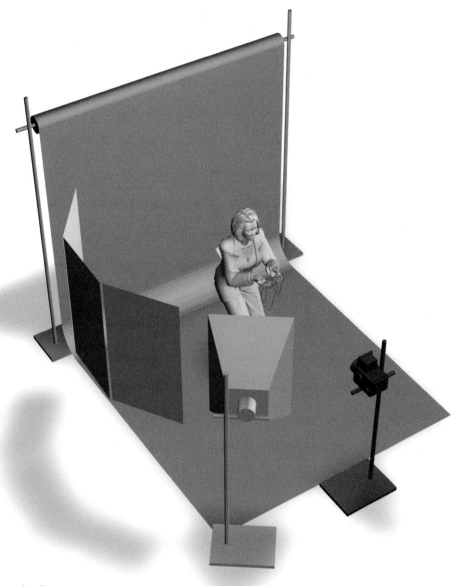

tricia

Hand-coloring the jewelry in Photoshop helped to emphasize the designer's creations.

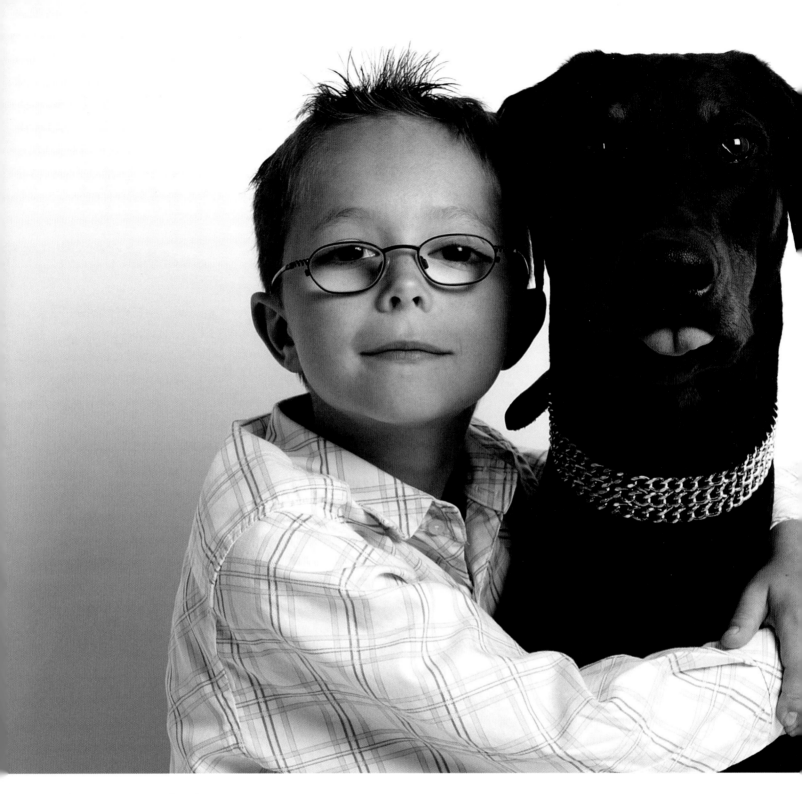

james and chester

Avoiding catchlights in the glasses frames while throwing sufficient light to capture detail in the dog's dark hair was the secret to this shot.

Karen Parker

Private commission

Various

50mm

1/125sec at f/16

Electronic flash

"James loves his dog Chester and that was the key to this shot—there are few greater bonds than a boy and his dog. A white backdrop extended over the floor and two large softboxes (suspended at 45 degrees) lit the set. It was tricky as any catchlights in the glasses would ruin the shot and Chester needed to be lit so that there was visible detail in his dark hair," says Karen Parker about this shot of a much loved family pet.

"I decided on no fill (reflectors or second light) as I didn't want to lose the edge of the shirt. It was a great shoot as when I started to take a few shots both subjects performed for the camera. They say you should never work with children or animals but by shooting them together you can achieve something unique and show what true friendship is all about."

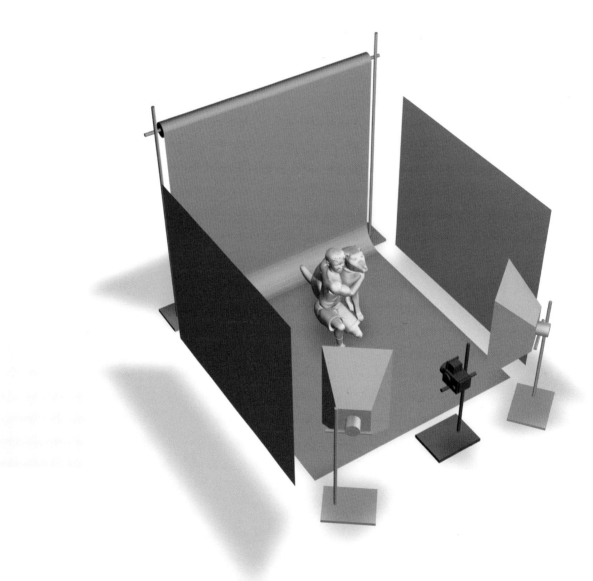

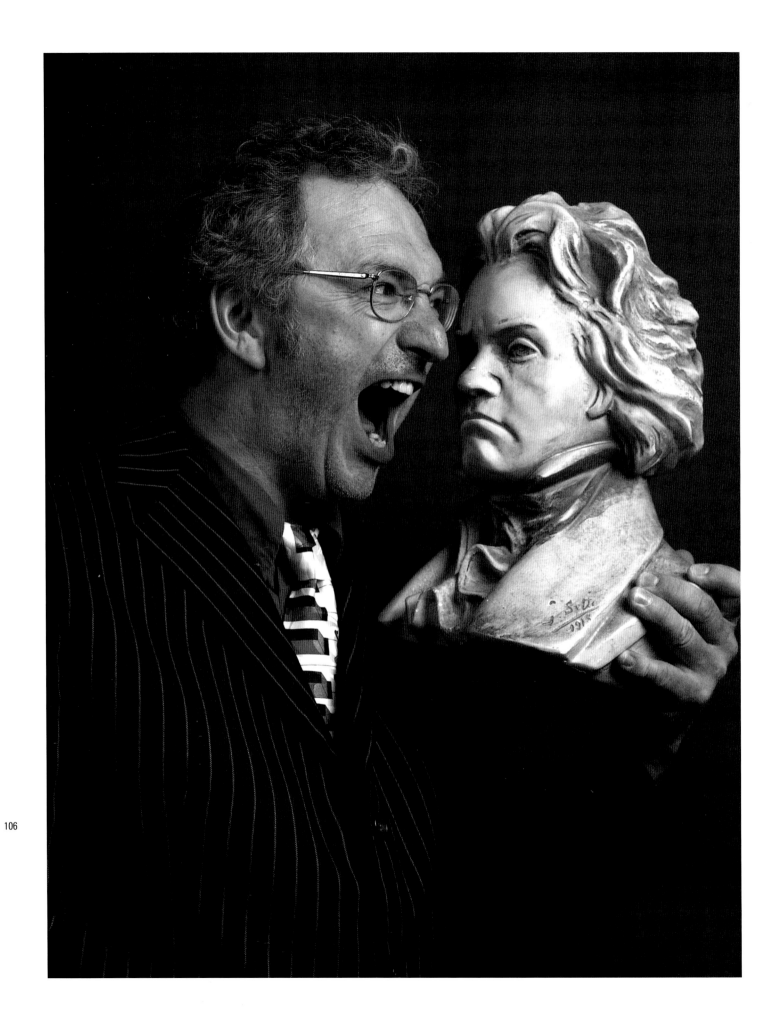

"Big George Webley is a talented composer, presenter, and musicologist. His publicity image needed to get across his great personality, but also hint at his profession," explains photographer Karen Parker. "George had mentioned bringing the bust of Beethoven with him, and as soon as we were ready, he started to perform.

"I decided on a two light setup so that the detail in George's suit was retained and, as the lights were ceiling tracked, there was no telltale (or distracting) reflection in his glasses. I decided not to go in tight as a full shot could be cropped at a later date to provide further options. Finally, converting to grayscale gave the image more punch."

Karen Parker

Private commission

Publicity

80mm

1/125sec at f/16

Electronic flash

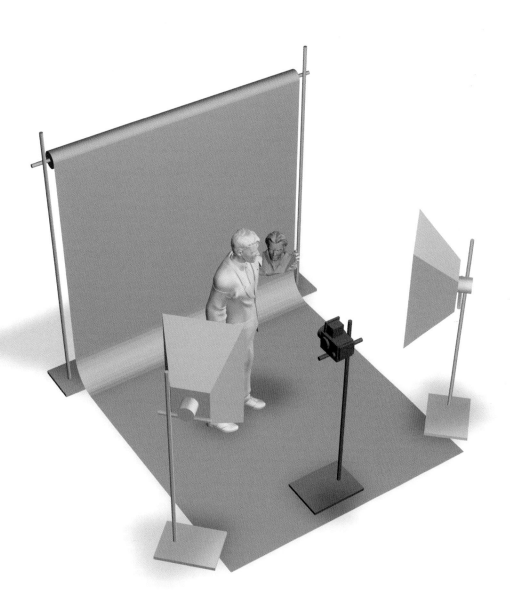

Big George Webley

A simple lighting setup helps bring out the details in this characterful publicity shot.

Controlling the light as it bounced off the various metallic, flat angled surfaces of the sculpture was the hardest aspect of this shot. Large black boards were placed behind and slightly to the side of the sculpture to absorb the reflected light, which was thrown via a head fitted with a large softbox and placed in front of a diffuser. This setup helped to ensure that the subtle differences in the light reflected from the sculpture were accurately captured, while the sculptor was evenly lit.

Jason Keith
Private commission
Various
22mm
1/90sec at f/4.0
Electronic flash

sculptor with sculpture

Using large black boards helped to absorb the light reflected from the various faces of the metallic sculpture.

two lights

This glamorous portrait for *FHM* magazine was taken using a couple of "Kino" lights—these flicker-free 4ft (1.2m) fluorescent tubes are balanced for daylight and come in a unit that contains four tubes. "They produce a different kind of light," Dunas explains, "and like any other tool, they're ideal for certain situations but not others. I like long exposure light sources such as these and tungsten because you get a creamy quality to the skin when you don't have the momentary blast of light inherent to flash."

Given the glorious tones in this image, there's no arguing with that. However, considering there are eight tubes, light levels are surprisingly low. With both units less than 1⅔ft (0.5m) either side of the camera, the exposure still didn't rise above 1/30sec at f/5.6.

It's also worth commenting on the pose and composition. You don't always need your subject to be looking at the camera, or even have their eyes open, for it to be a successful image.

Jeff Dunas

FHM magazine

Various

140mm

1/30sec at f/5.6

Fluorescent tubes

katherine heigl

Using specialized continuous light sources gives skin tones a creamy texture.

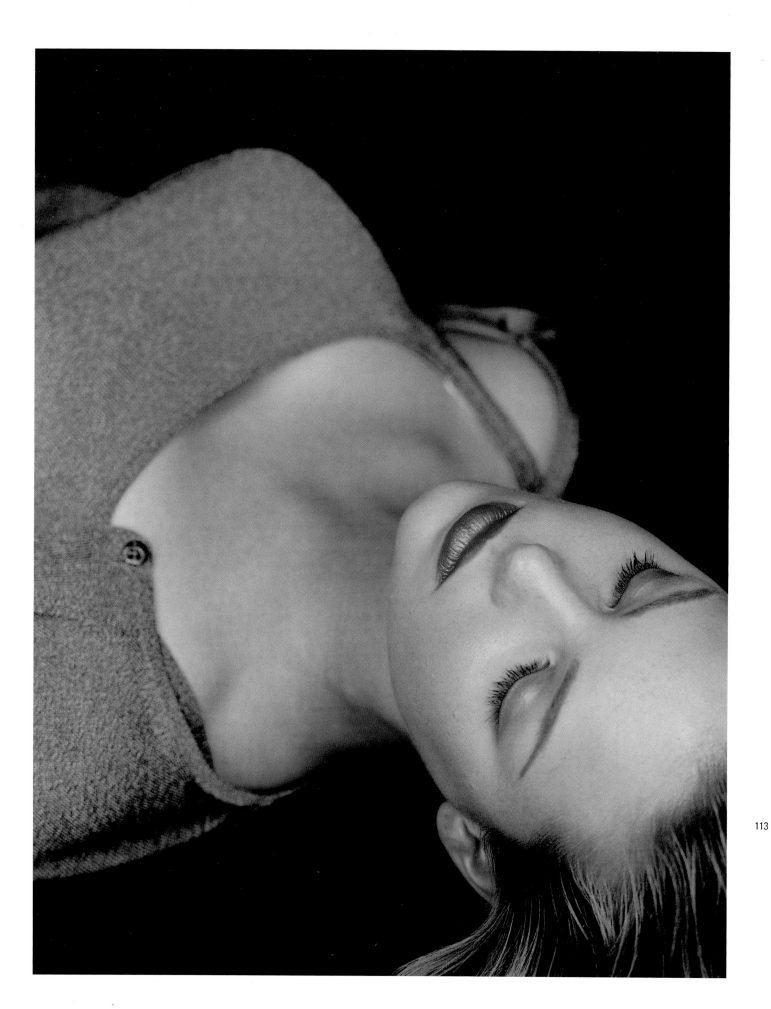

113

When most parents commission a portrait of their young daughter, they are seeking a traditional, pretty image. Others, though, are more open-minded, and appreciate a less conventional and more artistic treatment—like the one shown here.

"She was an extremely mature little girl for her age," says photographer Tamara Peel. "She could look straight through you, and that's what I wanted to show. I really love the eerie, haunting quality of the picture, accentuated by having the camera slightly above eye height and angled down."

Peel likes to keep the lighting simple, so she used two studio flash heads fired into umbrellas placed at 45 degrees, with the child 3ft (0.9m) in front of a plain white backdrop. To bleach out the skin tones the film was overexposed by two stops, and the negative was printed onto lith paper to enhance the result.

Tamara Peel

Private commission

Album/wall portrait

35–70mm

1/60sec at f/11

Electronic flash

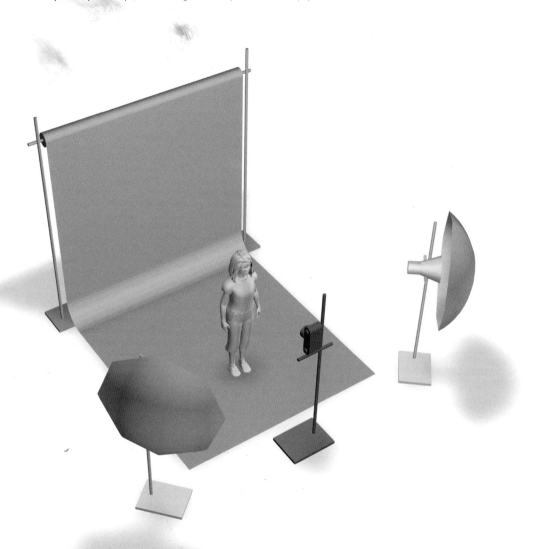

the eyes have it

Capturing the aspects of maturity in youth requires sympathetic and sensitive lighting.

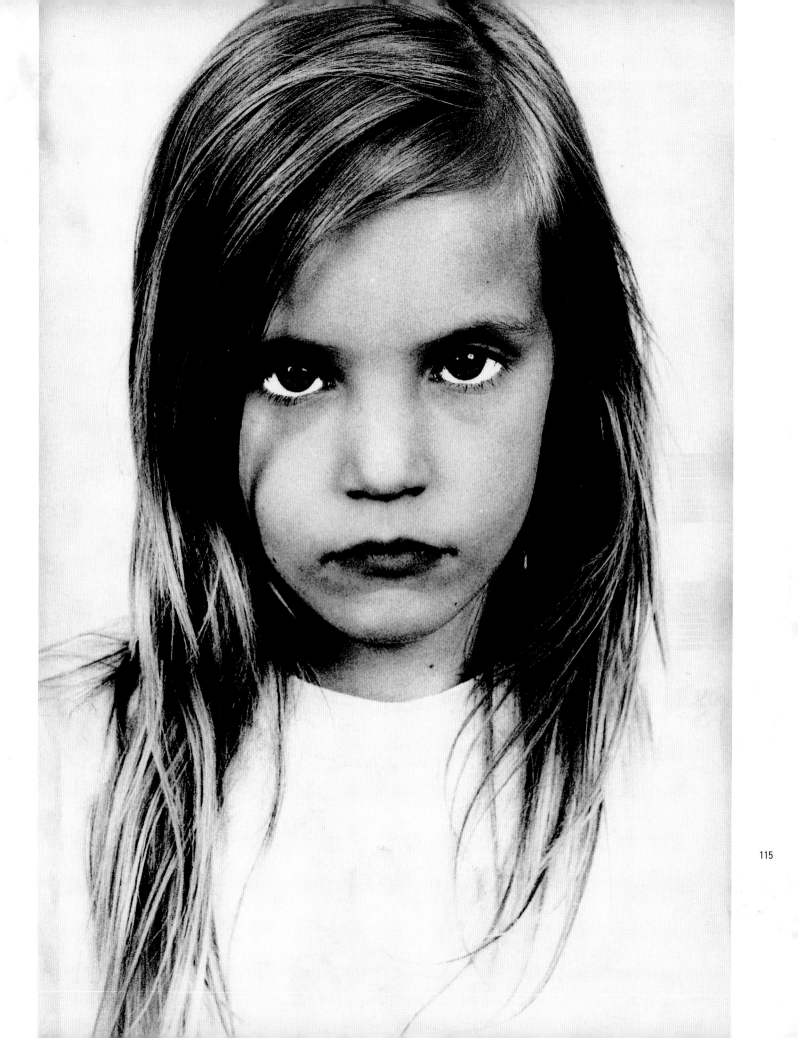

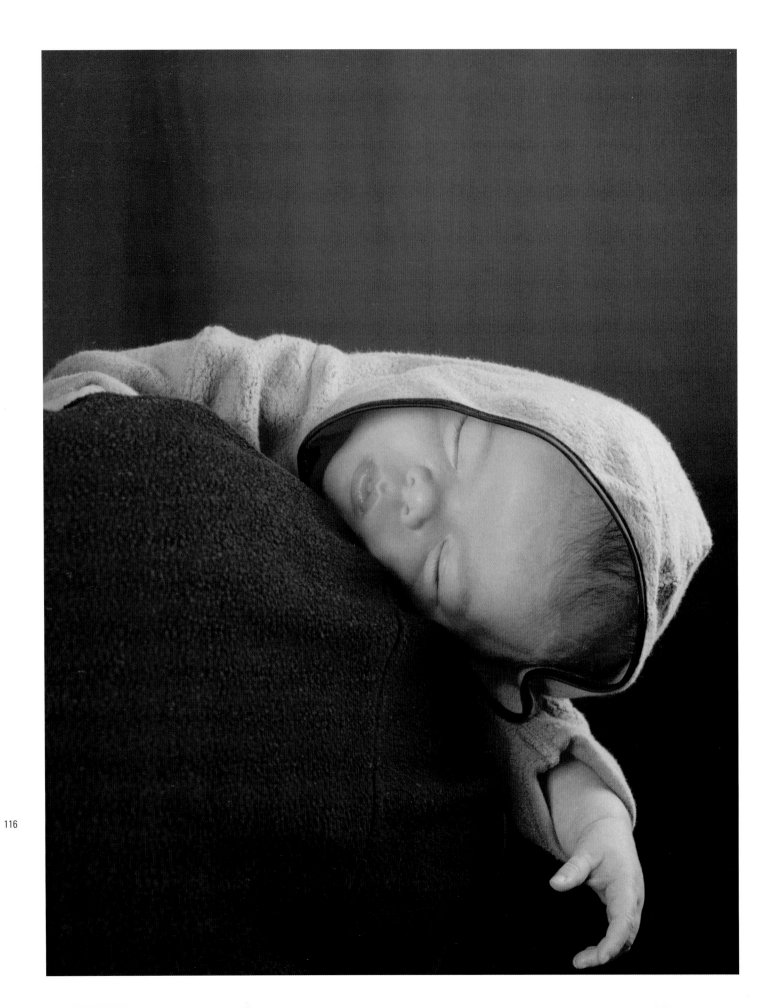

It's all very well setting up your lights carefully, but what happens if—as is often the case with children—your subject moves around a lot? It can be a problem, but sometimes the subject's unexpected positioning can produce attractive results that you hadn't planned.

In this image, for instance, photographer Karen Parker set up the lights in a relatively standard way, with one softbox placed each side at 45 degrees for even lighting. However, in the course of the session the subject moved slightly more toward one of the lights than the other, and away from the angle on the background intended. Noticing this engaging expression, Parker quickly grabbed a shot or two, even though the lighting wasn't as she'd intended. The result, though, is refreshingly different.

🚶 Karen Parker

↻ Personal project

◉ Portfolio

◎ 110mm

⏱ 1/60sec at f/11

💡 Electronic flash

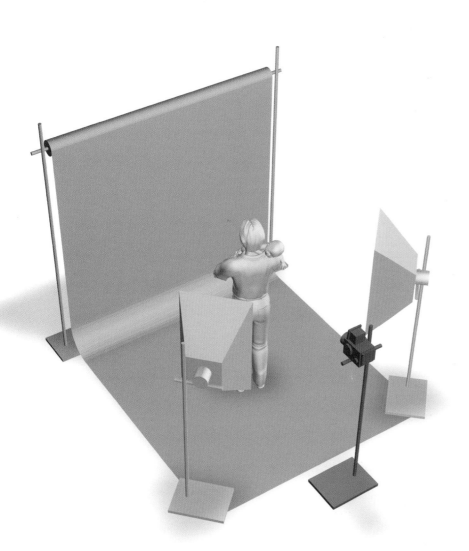

sleeping baby

Unconventional lighting can result from grabbing a shot at an unexpected angle.

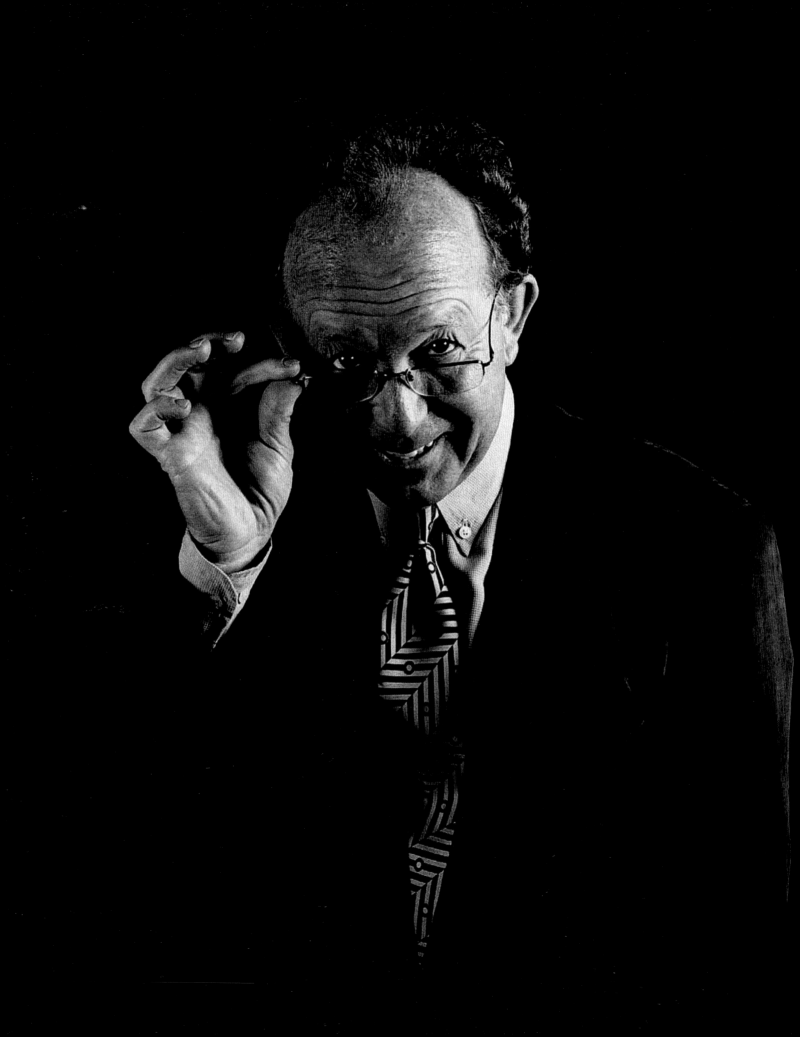

These pictures were taken for a series of advertisements for an opticians—and naturally all of the people shown are wearing glasses. For that reason photographer Karen Parker placed the lights higher than usual, to minimize the risk of distracting reflection.

Since the advertisements were appearing in newsprint, she wanted a strong, punchy, graphic image, and so positioned two softboxes farther round to the side than she would normally have done. The softbox at left was set to a weaker output just to fill in the shadows on this side. A folding triple reflector angled underneath the subject ensures that the face isn't underexposed.

- Karen Parker
- Hammond & Dummer opticians
- Advertisement
- 110mm
- 1/60sec at f/11
- Two softboxes

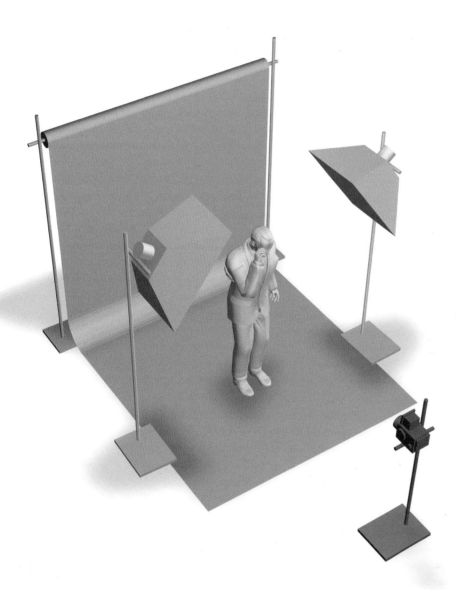

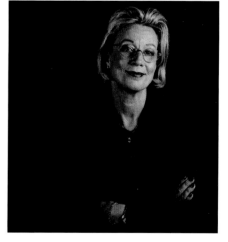

optical shots

119

Photographing people wearing glasses requires a high lighting position.

environmental portraits

The editorial approach of Dennis Schoenberg

Some portrait photographers go into a session with relatively fixed ideas about what they want to do—but Dennis Schoenberg is not among that number. "I always ask the people I'm going to photograph how they would like to be presented, and whenever possible I incorporate their views into what I do. Working together with someone, and being able to show them in their own light, is very much my preferred way of working."

Shooting largely for editorial use, Schoenberg takes an environmental approach to his subjects, almost always showing them in their common surroundings. "I really dislike studio work, where the person is cut off from the real world. It's very difficult to judge a person solely on the basis of what they look like and what they're wearing. It's nicer for the viewer to see them in a situation that tells you about them, which is why I strongly prefer to shoot on location—using

a real-life background that tells you more about the person. In many ways my shots are very simple, but I really like that straightforward kind of aesthetic. It's also practical, as often you only have no more than 15 minutes with the person."

cowboy artwork

Most portrait photographers organize their compositions so as to concentrate attention on the subject, but here quite the opposite approach has been followed. By placing the person, dressed all in black, in front of an enormous piece of bright artwork, a dynamic tension has been established between the subject and his surroundings. "The cowboy painting hangs in a restaurant and is by one of my favorite artists," says Schoenberg. "I knew one day I would photograph someone in front of it, and when I was asked to photograph this fashion designer it just seemed right."

"The lighting for the picture is entirely natural—which is unusual for me—and comes from a huge window over on the left-hand side. It was a fairly sunny day, and there was plenty of light bouncing around."

- Dennis Schoenberg
- *i-D* magazine
- Editorial
- 28mm
- 1/30sec at f/5.6
- Ambient light

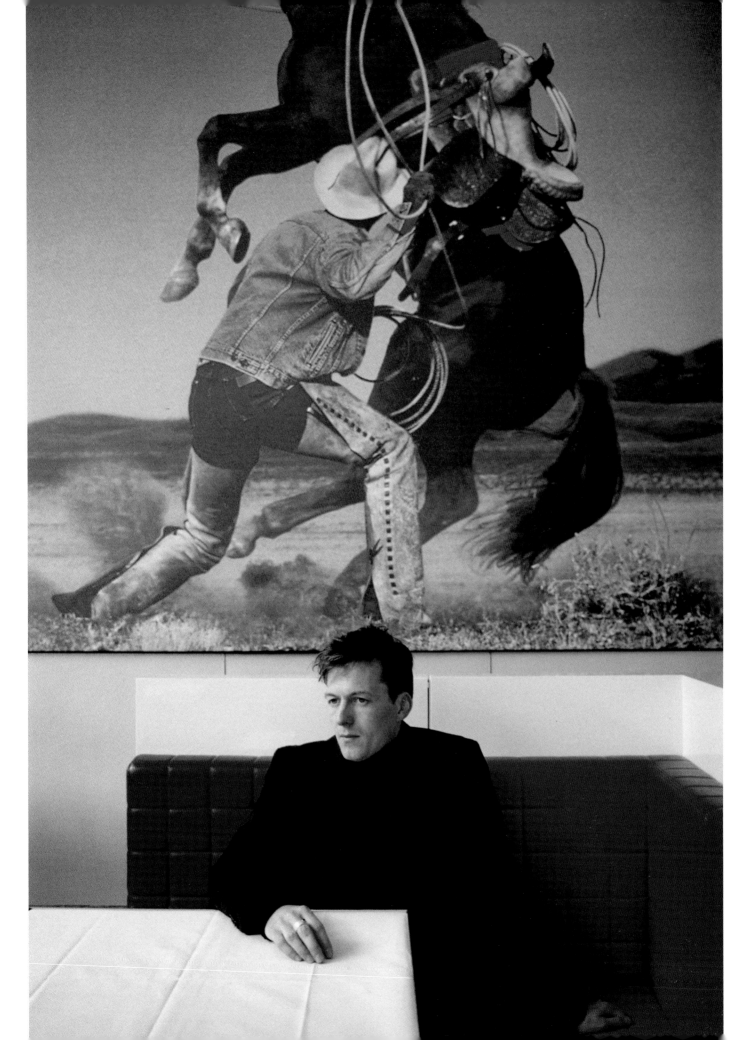

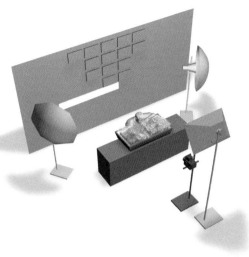

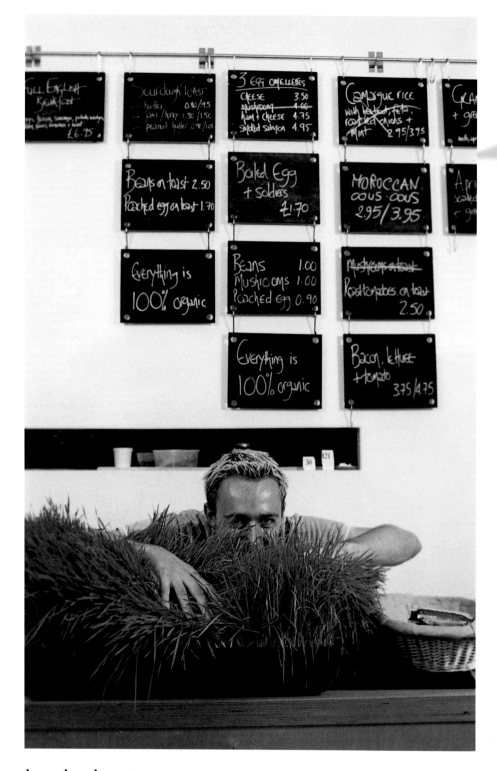

buckwheat grass

One of the best ways of breathing life into a picture is to get the subject to move about or interact with their environment. "I just asked the guy to mess around," says Schoenberg, "and photographed him when something interesting seemed to be happening."

Because the background was equally important, it was lit separately by means of two studio heads fired into umbrellas at 45 degrees. A single softbox over the top of the camera illuminated the main subject. Lots of test Polaroids were taken to ensure the balance of the exposure was just right.

Dennis Schoenberg

i-D magazine

Editorial

90mm

1/60sec at f/8

Electronic flash and softbox

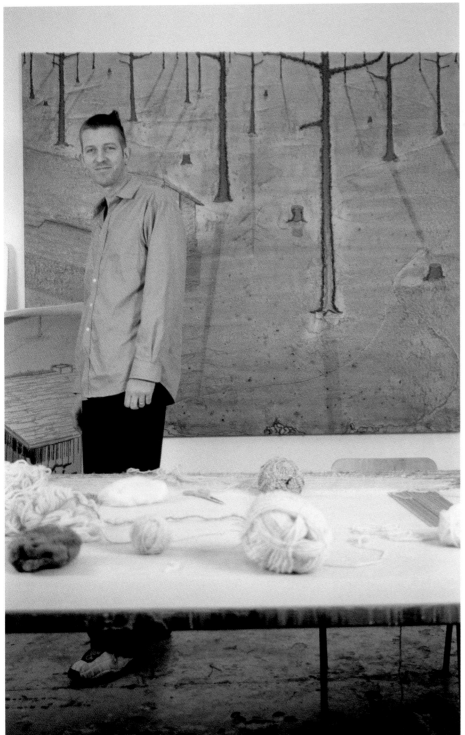

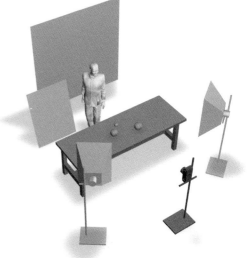

painter

"You see a lot of bland photographs of painters standing in front of their paintings," says Schoenberg, "and I wanted to do something a little more interesting."

He introduced a table in the lower third of the frame, which included elements used in the making of the artwork. The table was rendered out of focus and allowed to overexpose. This created a strong sense of depth as well as providing a narrative.

Since the painting was an important part of the shot, two softboxes were evenly placed 6ft (1.8m) either side of the photographer, fairly high up.

- Dennis Schoenberg
- *i-D* magazine
- Editorial
- 50mm
- 1/30sec at f/16
- Two softboxes

One of the easiest ways of changing the tonality of a white background is to not light it directly—only your subject. In this way it's the light that spills behind the subject that determines how bright or dark the backdrop is—and that can be regulated by how far it is placed behind the model and by the nature of the lighting. Cross-processing, though, adds another dimension to this equation—as in these images, where it transforms an unlit white paper roll with a rich blue-green tone.

This effect was not simply a matter of chance: photographer Karim Ramzi deliberately placed the background 10ft (3m) behind the subject, and used just two lights close to the camera. Ramzi explains: "The main light is a small softbox over the camera. However, with cross-processing the contrast is high, so below the softbox I used a second light with a white reflector to soften the shadows." The result of all this is a bold, vivid portrait bursting with color and detail.

ⓐ Karim Ramzi

ⓑ Authentic Panama

ⓒ Catalog

ⓓ 150mm

ⓔ 1/500sec at f/11

ⓕ Electronic flash and softbox

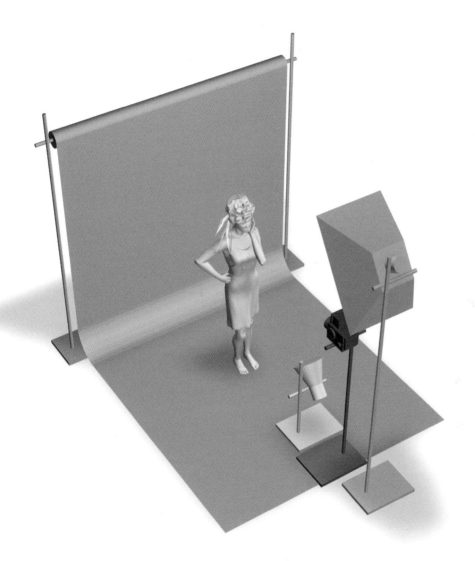

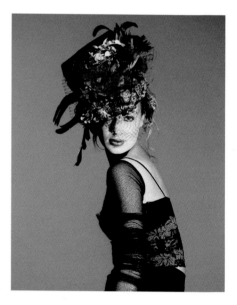

floral portrait

Lighting and processing options offer bright, vivid colors.

This is a more traditional take on the subject, taken during the same shoot.

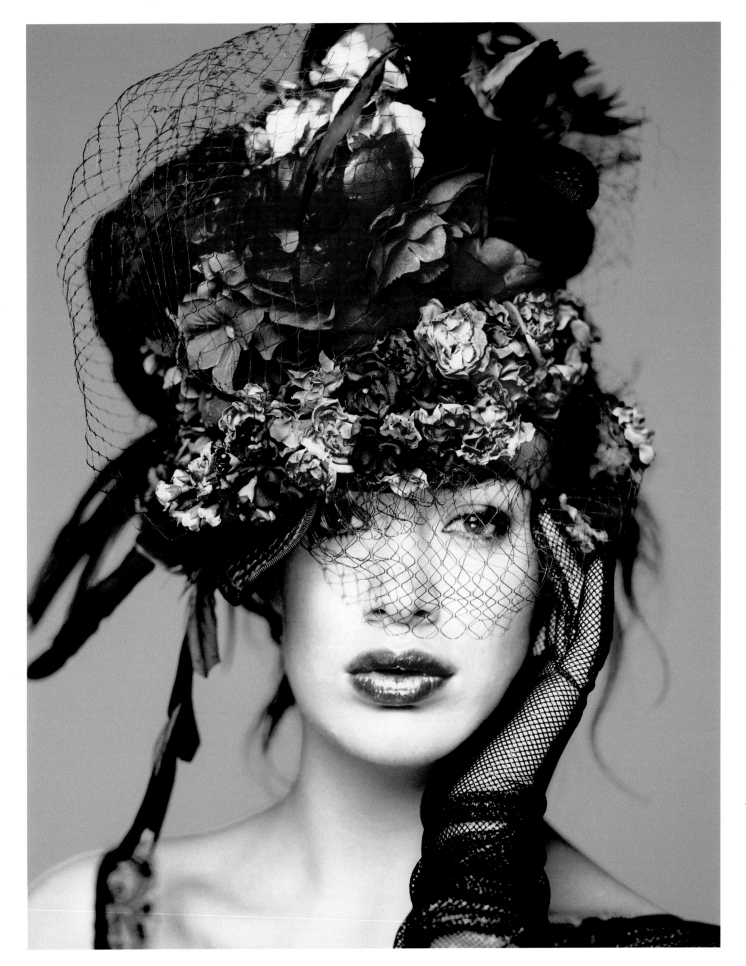

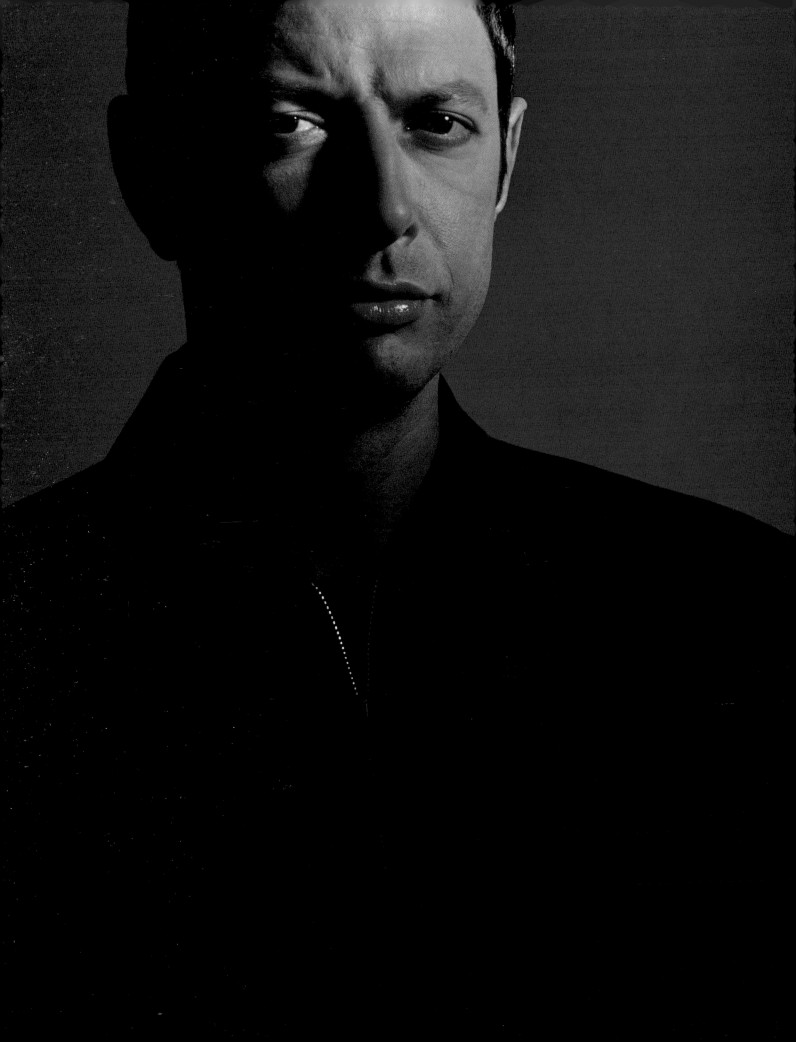

more complex setups

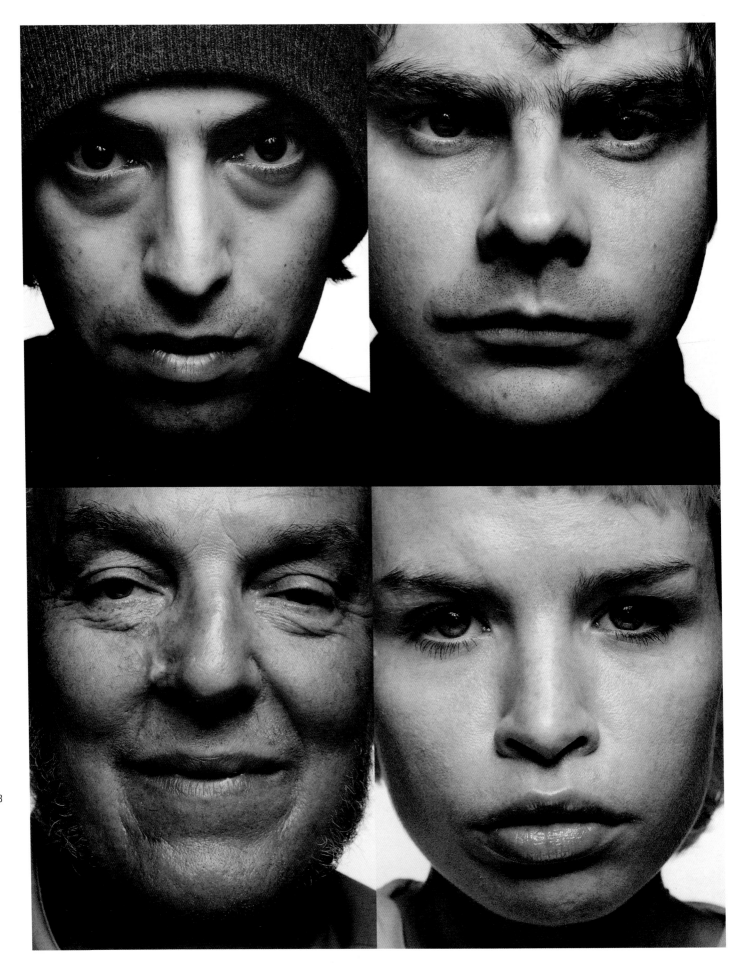

A war photographer once famously said, "If your pictures aren't good enough you're not close enough." This is not a criticism that can be leveled at these portraits, which are cropped extremely tight, so that the tops of the heads and the ears are out of frame. This was achieved using a 360mm lens on a 10 x 8in camera—the telephoto focal length minimizing facial distortion and allowing the camera to be kept at an acceptable distance from the subject. The large format produces images with exceptional clarity—and this is enhanced by the choice of lighting.

"With this set of images I wanted to get the personality of each individual naturally," says Hiroshi Kutomi. "I focused just on the face without the need for any image helpers such as hair stylists."

In each case the subject is sitting, and two flash heads have been used. The main light, fired into a brolly, is over the top of the camera; while the second, a softbox, is below it. Large black polystyrene boards on each side of the subject create the shadowed edge to the face. Although little of the background can be seen, it was in fact lit by means of heads, with output set to produce a clean, crisp white.

Hiroshi Kutomi

i-D magazine

Editorial

360mm

1/125sec at f/45

Electronic flash and softbox

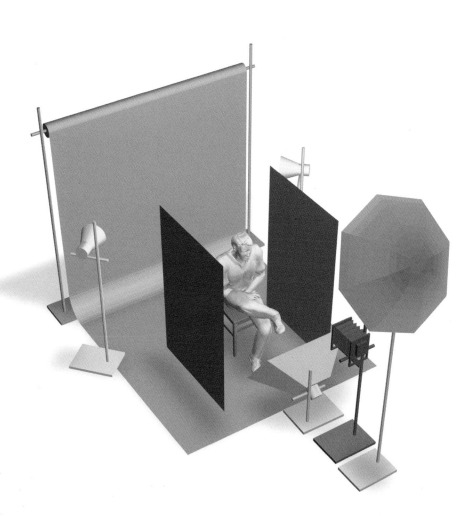

character close-ups

Go in close for maximum impact—but light carefully.

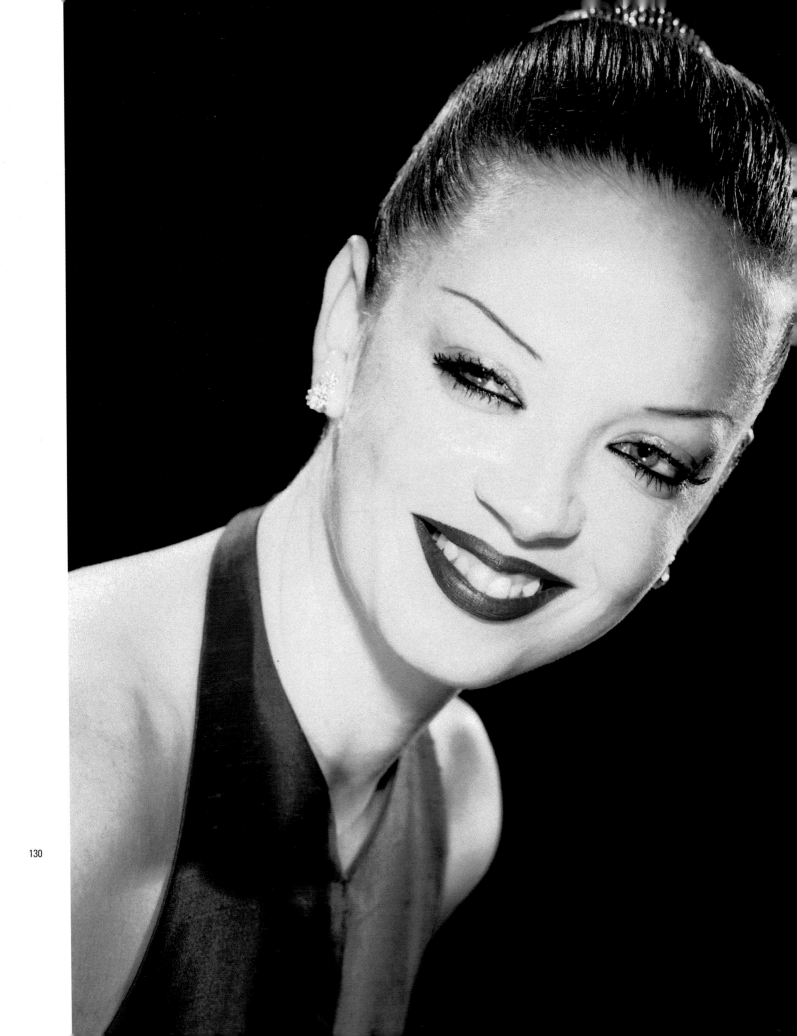

If you want your pictures to stand out from the crowd, you need to try something different. Here, the photographer has combined a "Hollywood" lighting technique with an unusual film choice to produce an image that is at the same time contemporary and traditional.

Three flash heads were used, all fitted with snoots to concentrate and limit the light. Two providing the backlighting were set at about 45 degrees behind the subject, with the third directly above the camera. This was also then supplemented by a foil bounce board underneath the lens.

"I was after that faded color dye effect that you get with older emulsion," says Dave Willis, "so that the shot looked like it was older than it was—as if it was taken in the 1950s or '60s. By using the wrong film for the job—a tungsten-balanced emulsion with flash—I got a nice blue cast, which was just what I was after."

⊕ Dave Willis

⊖ *Kerrang!* magazine

◉ Editorial

◎ 180mm

⊘ 1/60sec at f/5.6

◉ Electronic flash

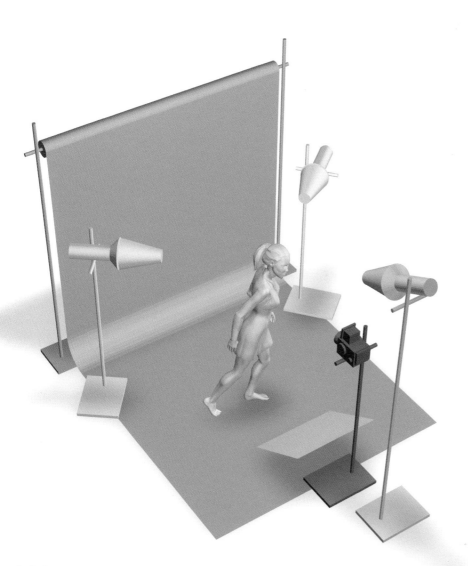

shirley manson

Don't be afraid to break the rules to produce something original.

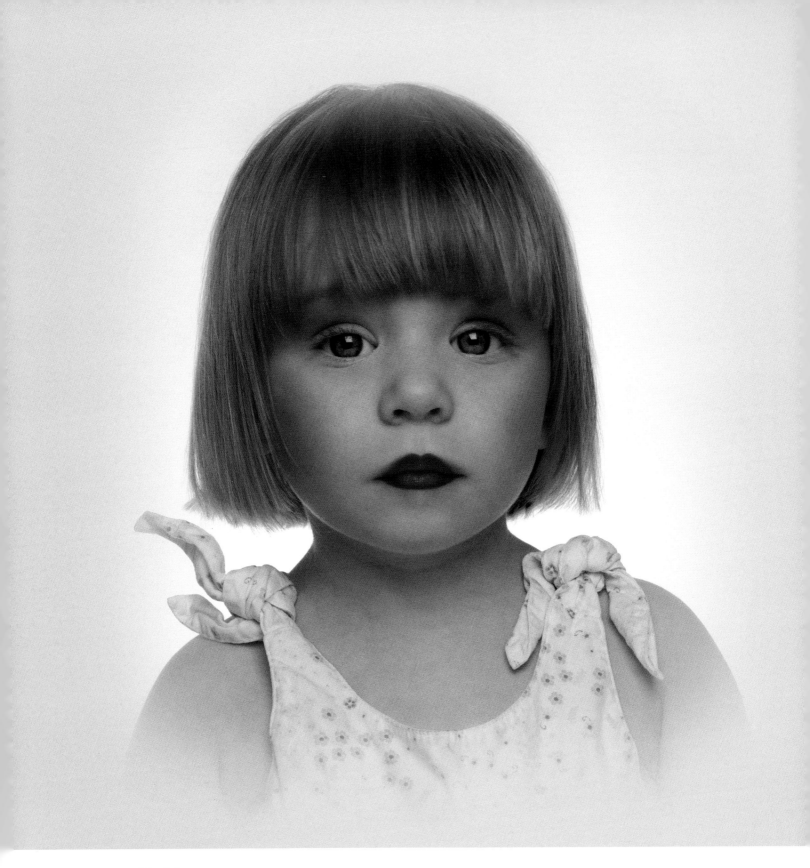

beautiful bea

The use of dramatic makeup and creating a vignette in Photoshop during postproduction introduced an old-fashioned, hand-tinted look to this image.

"My idea with this image was to produce a child portrait that had some of the atmospheric qualities of early photographic images that were hand-colored," says photographer Anita Clark. "Bea loves to play with makeup and so was very happy to have a makeup artist work on her. On looking at the images after the shoot, I decided I did not want to mute the colors, but I decided to apply a vignette effect to the edges of the shot. There were loads of good exposures to choose from but I liked this one the best as Bea has a serious expression and her eyes draw you in. It is incredibly difficult photographing a child of this age, but so long as you have all the technical aspects sewn up before your little star arrives, it should go fine."

Ⓐ Anita Clark

◉ Private commission

◉ Portfolio

◉ 100mm

◉ 1/60sec at f/16

◉ Electronic flash

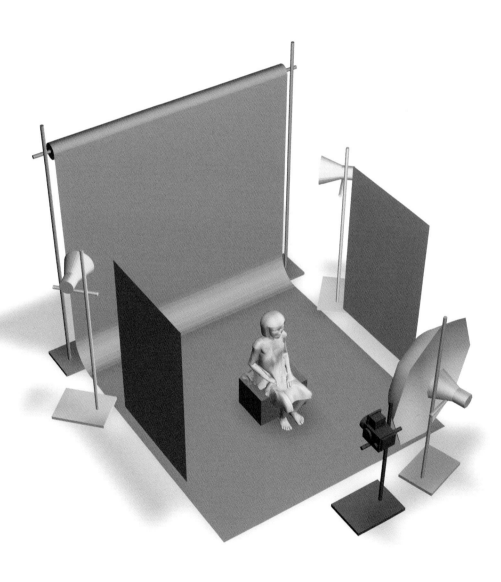

"I had two hours with actor Jeff Goldblum," says Jeff Dunas, "but in that time I had to do enough photography to fill eight pages. Generally you have a lot to shoot in the time available, so I plan all my pictures ahead of time, and have the lights arranged before the subject gets here. On this occasion we had four setups ready to roll, and were able to move fluidly from one to the other. That's important, because then I can keep the attention of the subject riveted on what I need, and nothing is left to chance. You don't want to give them the opportunity to fall back into thinking about their own life or wonder what they're going to do later, because then you've lost it."

This picture was taken using an interesting and original technique. The vivid blue was produced by fitting a blue filter over the lens. The white studio was flooded with light by bouncing two flash heads off the ceiling. Goldblum was then lit by just one head fitted with a grid spot to concentrate the light, and an orange gel to compensate for most of the blue of the filter.

Jeff Dunas

Venice magazine

Various

90mm

1/500sec at f/8

Electronic flash

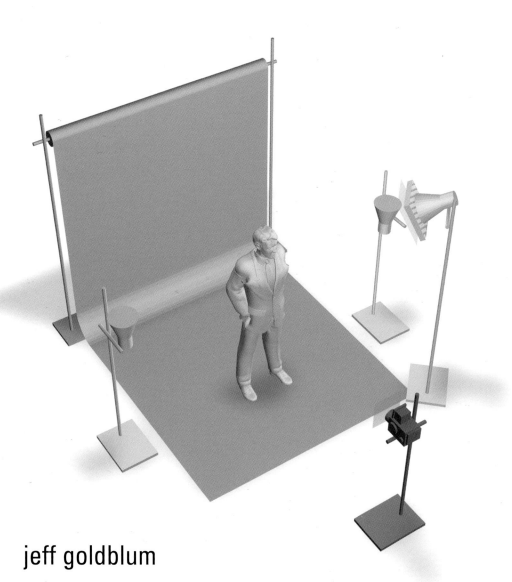

jeff goldblum

Using a compensating lens and camera gels helps produce vivid colors.

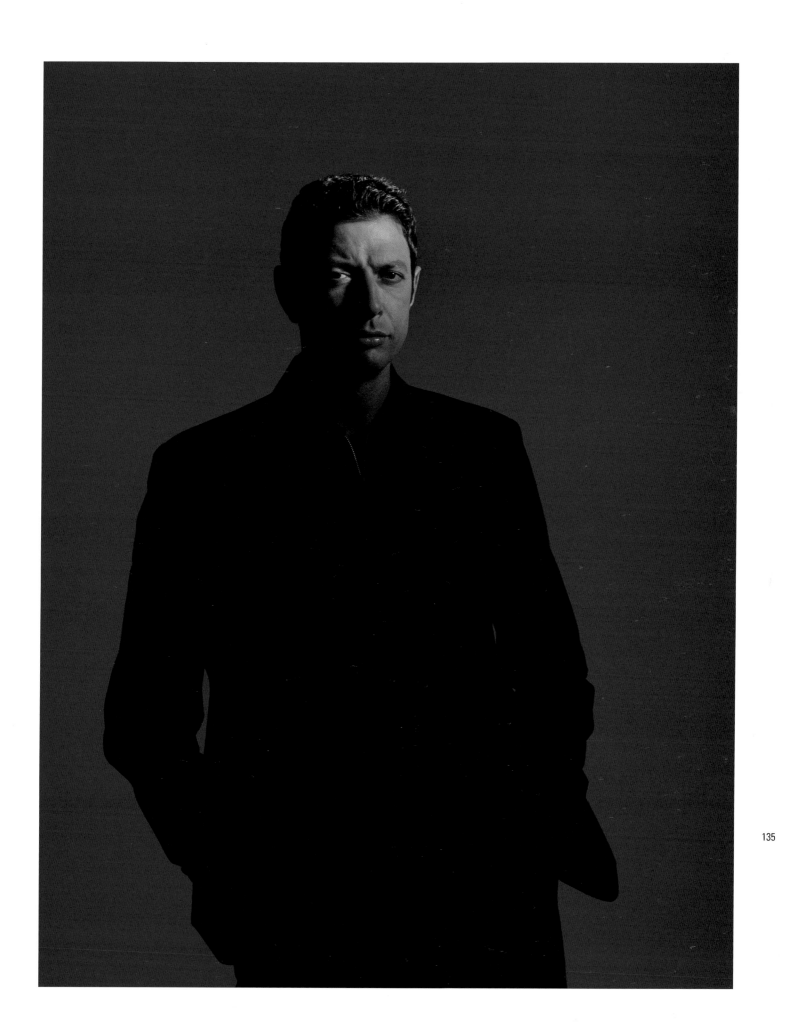

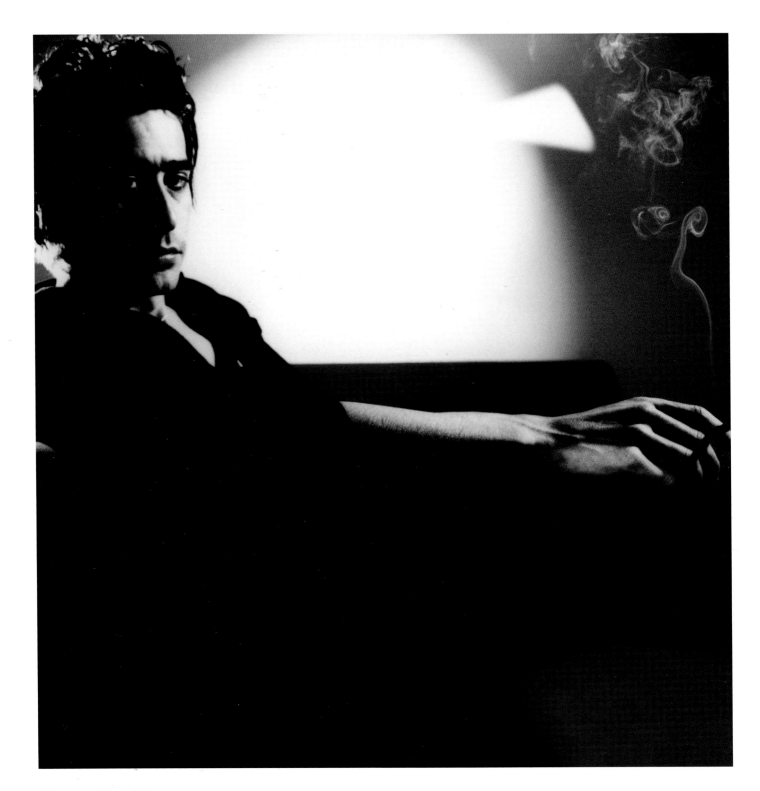

theatrical spot

Don't just use the same old setups—be imaginative, experiment!

Simple lighting doesn't have to be boring, providing you're willing to take a few risks. Only three heads were employed for this picture, but the effect is considerably more dramatic than a normal configuration would give.

What catches your eye immediately is the large circle at the back, similar to the spotlight effect you sometimes see in a theater. This was created quickly and easily by mounting a snooted head on a floor stand behind the seating.

The lighting for the subject comes from two units: a head in a standard dish on the right-hand side and a snooted head to the left that backlights the hair. The stray triangle, by the way, was not intentional at all, and was the result of surprisingly strong stray ambient light coming in through a skylight.

Dave Willis

Headswim (pop group)

Publicity shot

80mm

1/60sec at f/11

Electronic flash

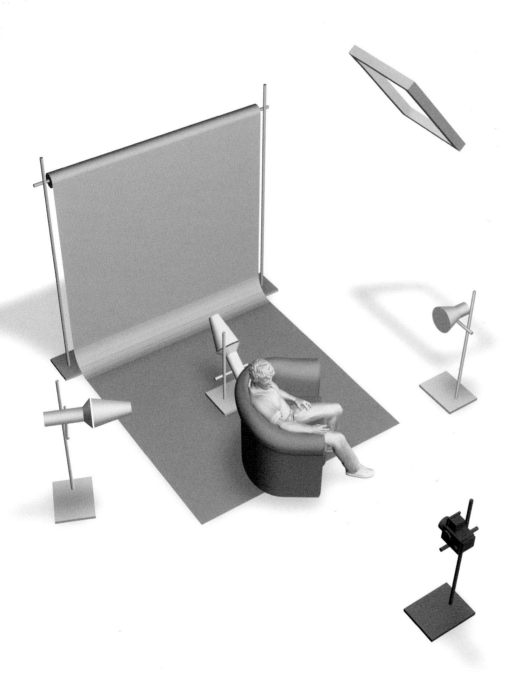

industrial plating

Using gels can help give shots an industrial feel.

Neil Warner

Irish Finishing Technology

Brochure

110mm

1/500sec at f/8

Electronic flash

One of the simplest ways of giving corporate portraits an "industrial" feel is to use gels over your lights. Pretty much any color can be used, but pink and purple are extremely popular, and seem to work well in combination.

A head with a blue gel was placed behind the subject, facing the wall 6ft (1.8m) behind, from where it reflected back onto the metal plates in the foreground. There are two lights with pink gels. One is to the left of the photographer, slightly above eye height, in a 12in (30cm) reflector that allows some of the light to spill onto the background. The second is a snooted head to the left near the subject's shoulder, lighting his neck and gloves.

It's important when you're working with gels that at least part of the subject is lit with white light—providing a counterpoint to the richness of the gels. Here there's a head in a 12in (30cm) reflector off to the right, fitted with barn doors to control exactly where the light falls.

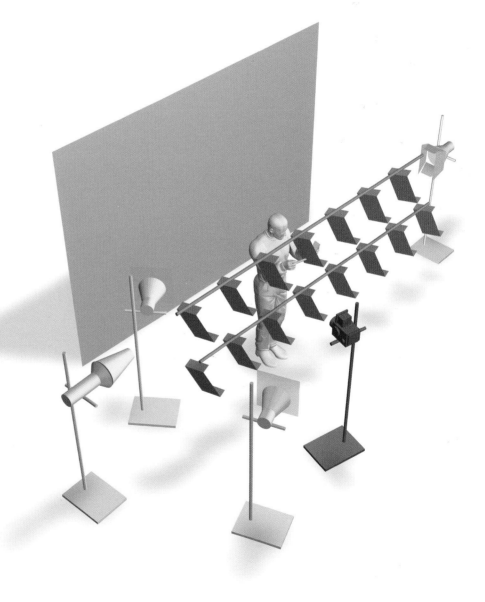

139

There's nothing to beat concentrating on the face with a close-up when a subject's appearance is really characterful. The lighting here is as straightforward as it is effective. The main illumination comes from a snoot just above the camera, with a reflector board placed below it to soften the shadows. The accents on the head come from two snooted lights that were set at about 45 degrees behind the subject. Getting the person to lean into the camera, and using an aperture of f/5.6, helps separate the head from the rest of the body.

- Dave Willis
- Private commission
- Publicity shot
- 180mm
- 1/60sec at f/5.6
- Electronic flash

publicity shot

Go in close when your subject has lots of character.

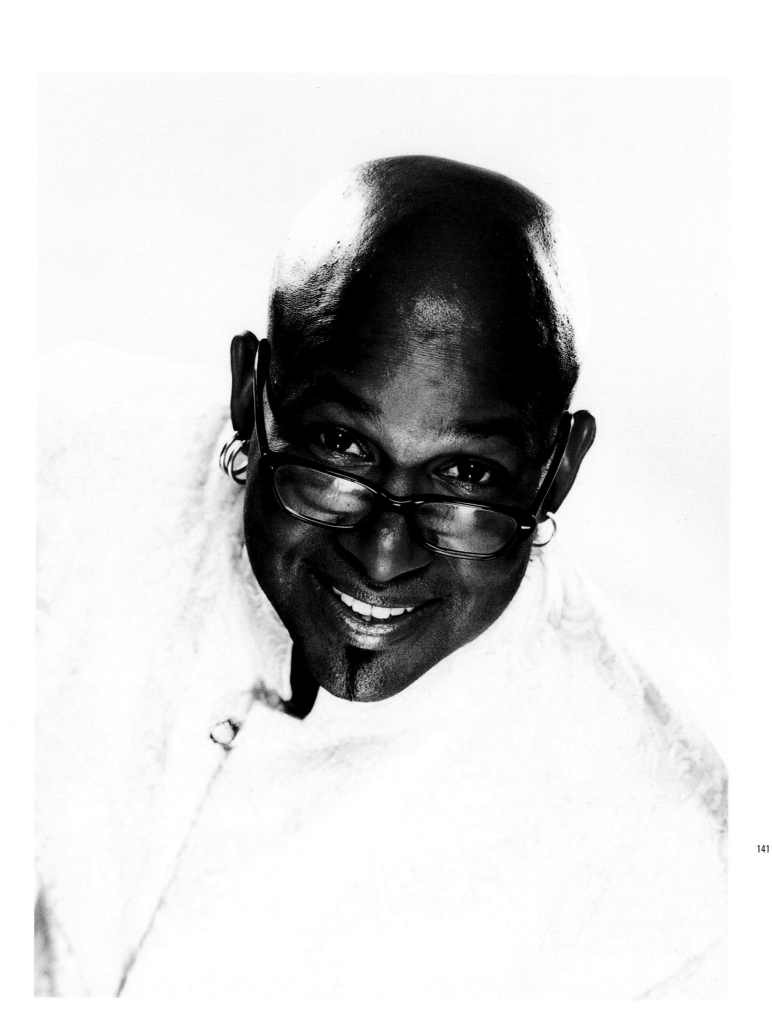

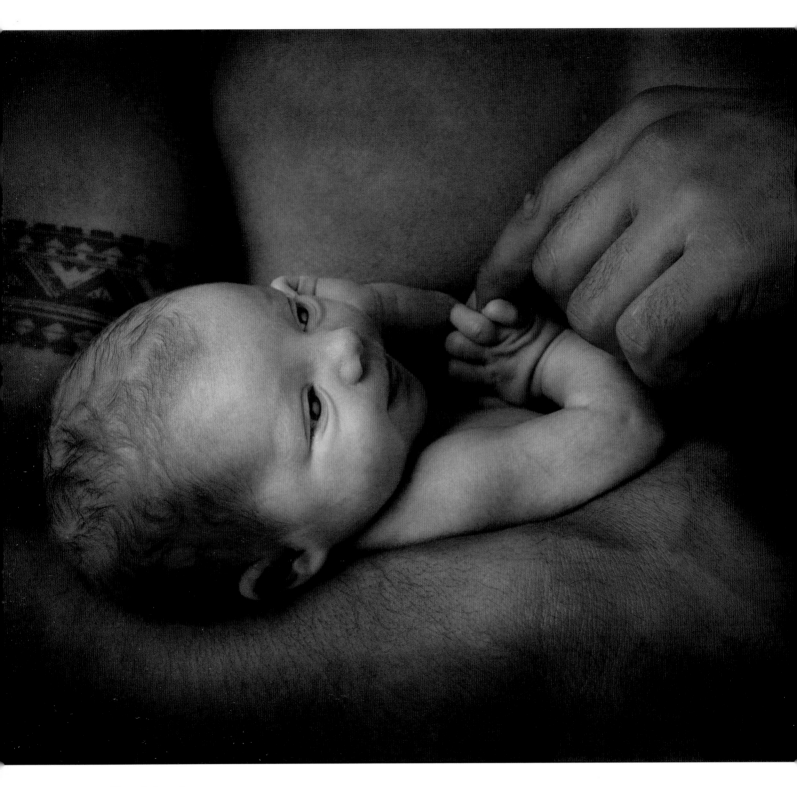

cradled baby

Timeless images require sensitive lighting if they're to avoid looking dated.

Contrasting small and large and young and old is always a surefire way of coming up with a winner—and especially so when the baby is so tiny and the adult so huge. Sympathetic lighting and skilful printing, though, have made all the difference here. The subjects are totally encased in a semicircular light tent made from sailcloth material, and three lights have been stacked to the left—at knee, waist, and head level, producing a sumptuously soft illumination. No additional reflectors were needed, as the material itself acted as a fabulous wraparound reflector.

During printing the baby was lightened in relation to the background subject and, the image having been scanned, the smile was exaggerated using Adobe Photoshop, and the catchlight in the eyes improved.

William Long

Personal project

Personal

110mm

1/125sec at f/11

Electronic flash

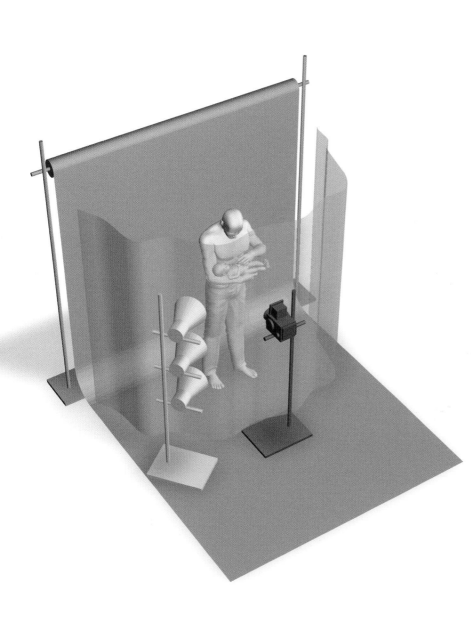

Quite a lot of thought went into capturing this straight-on portrait, defying the powerful simplicity of the result. A large silver brolly was placed high over the subject, slightly off to one side. Placed under the camera, a head with softlight reflector set to 1/10 power was used to act as a fill, while to the left of the subject's face black boards were set to absorb light, helping to add drama to the shot. Between the white background roll and the subject, two flash heads fitted with barn doors to reduce spill were placed either side of the subject, and in front of these were placed two boards that helped to reduce light bounce from the white background.

Jason Keith

Personal project

Various

65mm

1/180sec at f/13

Electronic flash

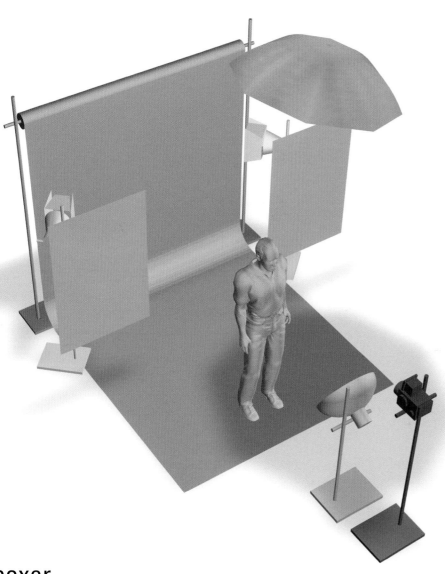

boxer

The head-on pose and the boxer's direct gaze belie the relatively complex lighting setup used for this shot.

"Australia has a lot of illegal immigrants," says Long. "Most come from ravaged nations close to our country, and I wanted to interpret and convey that sense of despair at such unrest. I had some wire mesh, and I just started to experiment."

Part of that experimentation involved trying out different lighting setups, with the final image illuminated with five bare flash heads directed through a white screen to give an overall diffuse but directional light. Skilled, sepia-toned printing by the photographer brought out the whites of the eyes and darkened down the edges of the print. This, with the direct, unblinking gaze of the subject, and tight cropping, results in a compelling and powerful portrait.

William Long

Personal project

Various

180mm

1/125sec at f/16

Electronic flash

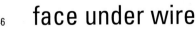

face under wire

Imaginative lighting and consummate printing result in a compelling portrait.

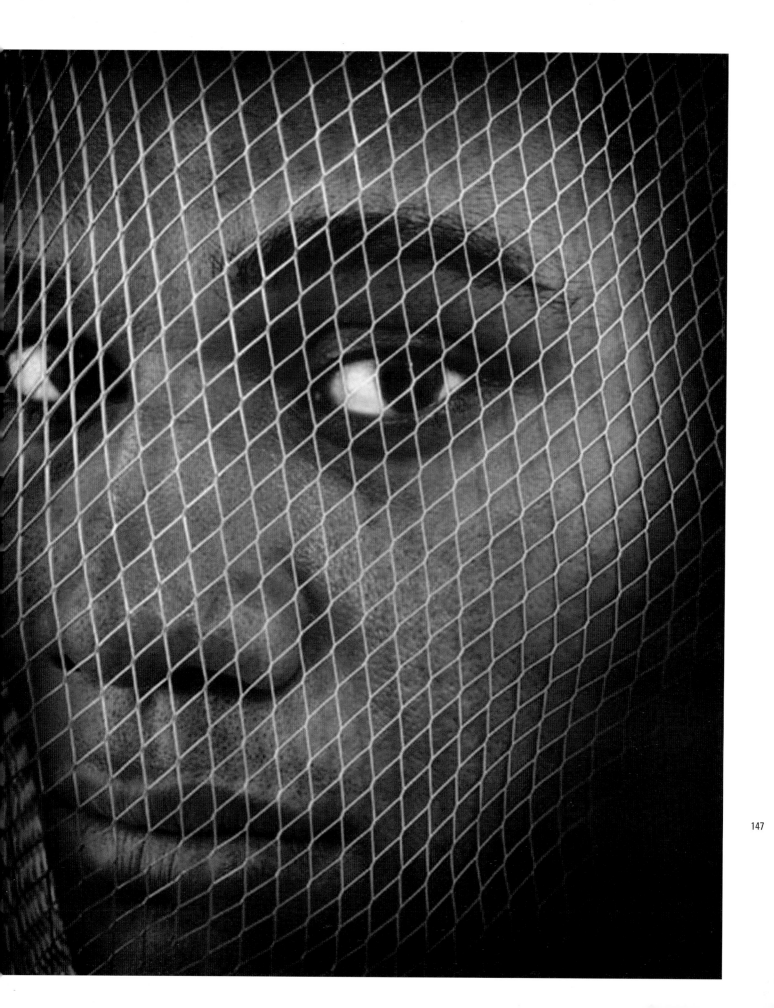

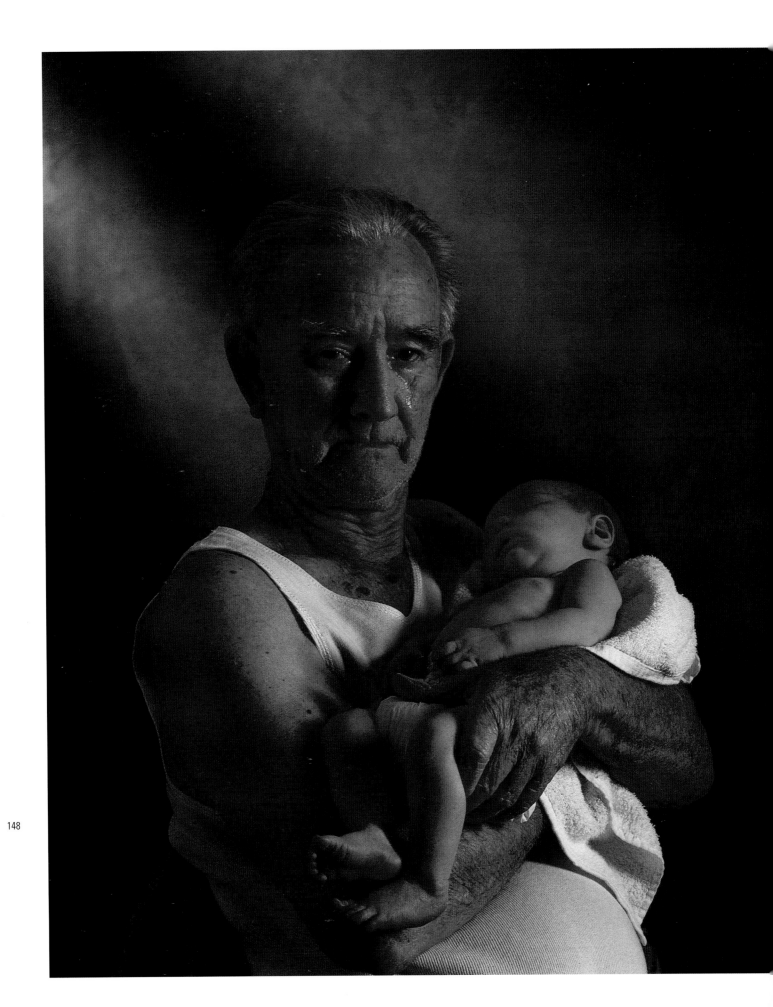

Although initially self-researched and self-commissioned, this image was intended to be used as a fund-raising gift for the UK-based charity FSID (the Foundation for the Study of Infant Deaths). They loved the image and it was used as planned—including in their Annual Report.

"The main points I was trying to convey were the passing of time, the generation gap, and the fact that the effect SIDS (Sudden Infant Death Syndrome) has on grandparents is often overlooked," William Long explains. "I wanted a grungy, minimalist effect, so I used the bare concrete walls of the studio I was in at the time. The main light is a large softbox to the right, with a smaller softbox providing fill-in from the left. I fired a third light fitted with a fine grid through a cutout to give the louver effect on the background."

The subject is actually the grandfather of the newborn baby, and the whole family, including the proud parents, had come straight from the hospital. The grandfather was conservative and shy, and had apparently never taken off his shirt in public before—yet was quite happy to do so for the picture when asked. "Tears came naturally during the course of the shoot," says Long, "as a result of questions and conversation. I often chat to the subject, to distract them from the tension of being photographed."

William Long

Personal project

Fund-raising

110mm

1/125sec at f/11

Electronic flash and two softboxes

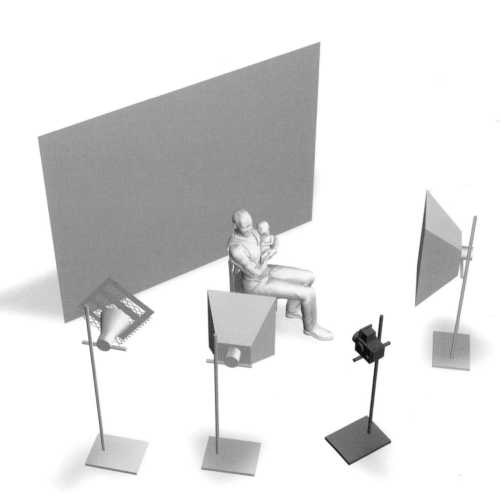

grandad with baby

A moving portrait across the generations receives sensitive handling.

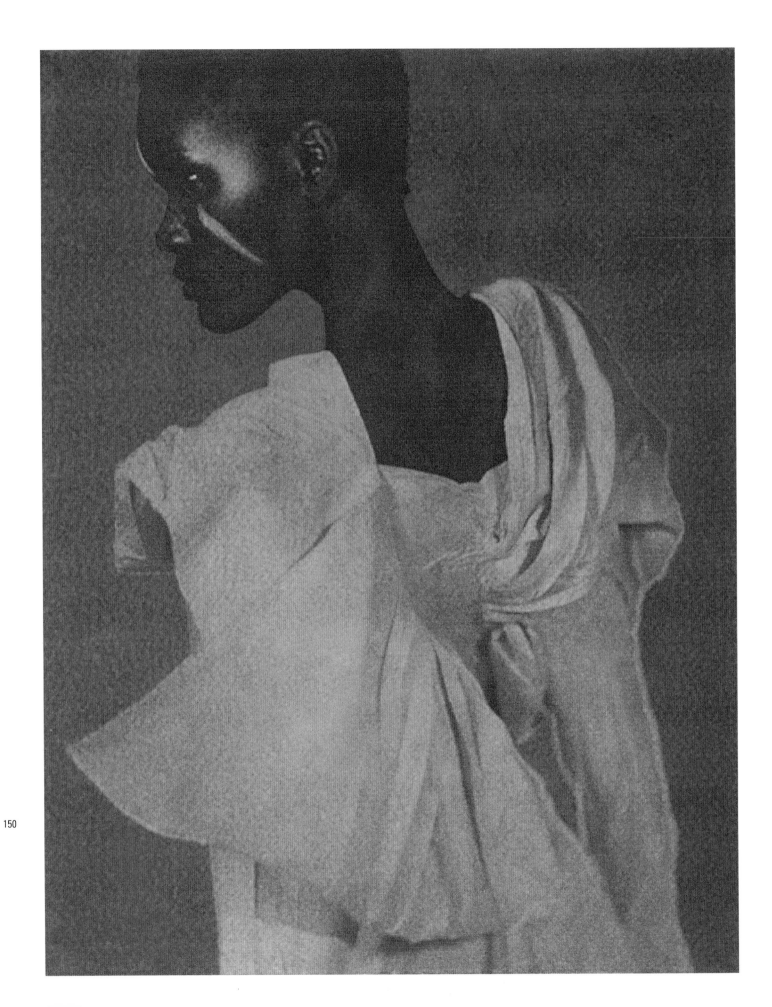

Patricia Canino uses continuous HMI lighting, typically employing around six heads to reveal the shape and texture of her subjects, and separating out the face and the body. She also places great importance on flags to control the direction of the light. "I make pictures that are to be touched with the eyes," she says. The background is lit separately, with red gels illuminating a red background to increase the intensity of the color.

The pictures themselves were taken using the big Polaroid camera, of which there are only two in the world. The camera is the size of a wardrobe, and produces a 20 x 25in instant image. In this case, the image was then transferred onto 250gsm textured art paper.

Ⓐ Patricia Canino
◕ *Audrey* magazine
◉ Editorial
◉ Standard
◔ Not known
◔ Continuous HMI lighting

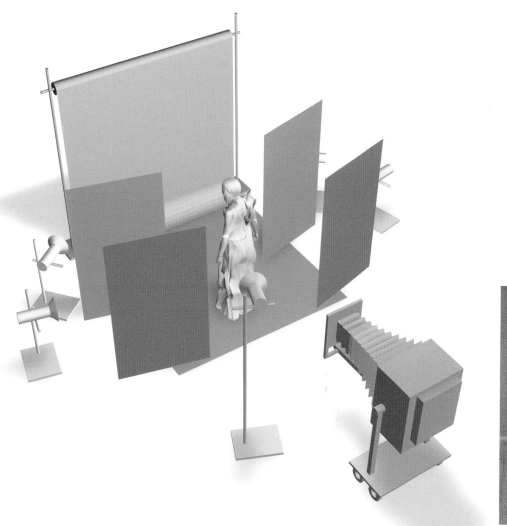

fine details

"Because I come from a movie background I don't have a standard lighting setup," says Patricia Canino. "Every shot is different. I just put the lights where they give me the result that I am after. For me, lighting is like making a sculpture or a painting."

This shot by Canino again uses sophisticated lighting to create a very theatrical and stylized effect. Note how the blue background brings out the cooler tones in the subject.

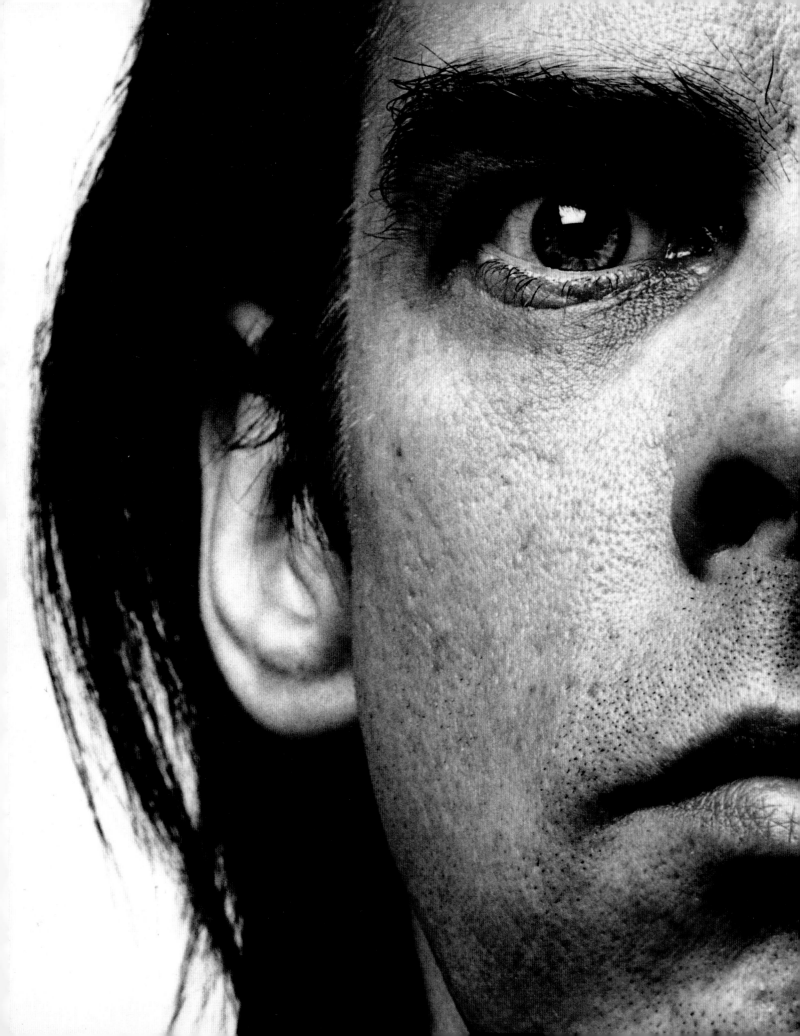

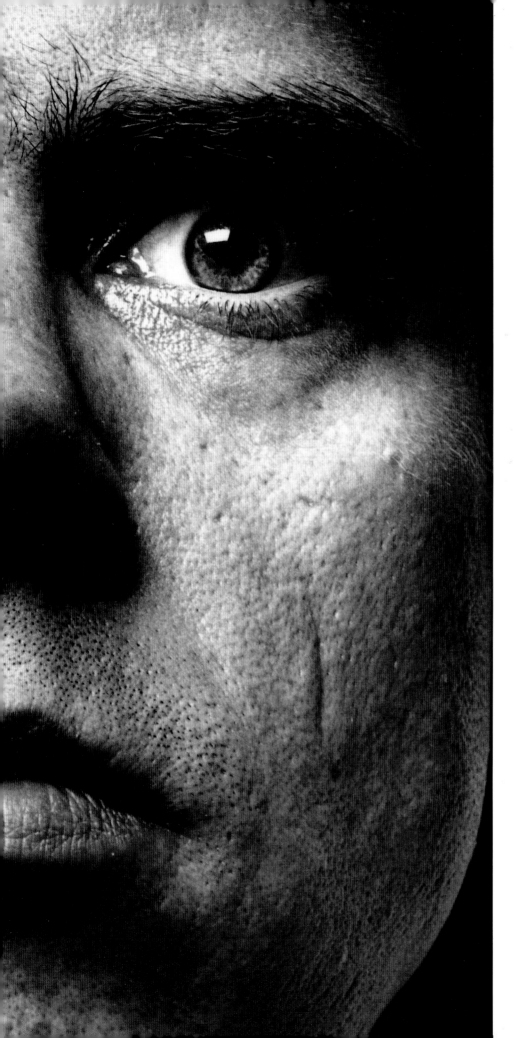

directory

photographer	Joachim Baldauf
address	Studio Baldauf
	Barmbeker Strasse 33
	22303 Hamburg
	Germany
telephone	+49 (40) 28 80 48 00
fax	+49 (40) 28 80 48 01
email	mail@joachimbaldauf.de
website	www.joachimbaldauf.com

Baldauf studied textile design in the German Alps before working as a graphic designer for the advertising industry; he came to photography through cover design. He loves the photography of the post-war years when very expressive results were achieved using the simplest means. In his work Baldauf aims to combine elegance, naturalism, and humor. He enjoys the family atmosphere that comes from working within a tight-knit team, and he views his models as muses rather than empty, emotionless shells.

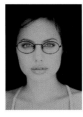

photographer	Patricia Canino
address	20 Impasse de Joinville
	75019 Paris
	France
telephone	+33 140 383 230
fax	+33 140 383 234

Patricia Canino is a Paris-based fashion photographer with a unique style based on movie lighting.

photographer	Fin Costello
email	fin@fincostello.co.uk
website	www.fincostello.co.uk

Costello has been a photographer since the late 1960s, specializing in portraiture. Most of his work is done for the music and magazine industries. "There are two streams to what I do, the first being simple portraits such as those in this book, and more involved theatrical pictures such as the record covers I have done for the rock singer Ozzy Osbourne. For many years I specialized in black and white portraits, where my influences were Richard Avedon, Bill Brandt, and W. Eugene Smith." During the 1980s Costello won several awards (album cover of the year) for this style of work. He particularly likes to print his own black and white pictures. Since the advent of digital imaging, in particular Adobe Photoshop, he has developed a more theatrical style. "I will often shoot several elements of the picture separately and comp them together in the Mac." He has worked with artists such as the Rolling Stones, Michael Jackson, Sting, Aerosmith, Kiss, and many other bands.

photographer	Jeff Dunas
address	P.O. Box 69405
	Los Angeles
	CA 90069
	USA
email	jrdphoto@dunas.com
website	www.dunas.com

Dunas is an editorial and advertising photographer working in the portrait, beauty, and reportage areas. His personal pursuits include nudes, portraits, and documentary photography. "I have been photographing nudes for over 25 years. This has been a dominant personal fine-art pursuit and a long and satisfying photographic exploration. Portraits are a very fulfilling photographic direction for me. One of the aspects of portraiture that pleases me enormously is its ability to freeze time, allowing observation that would not be possible in reality." Unlike many photographers, Dunas seeks diversion with a camera. He has been shooting street pictures in Paris, New York, and elsewhere for 20 years at every opportunity. He was voted Best People Photographer in the International Photography Awards Competition 2003.

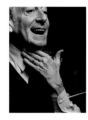

photographer	Mark Guthrie
address	26 St. Agnes Close
	London E9 7HS
	England
telephone	+44 (0)20 8533 1404
mobile	+44 (0)973 834 873
email	mark@markguthrie.com

Mark Guthrie has been a freelance photographer since taking an MA in Image and Communication at Goldsmiths College. Since then he has been concentrating on editorial portraiture, working for most of the weekend broadsheet supplements, and advertising work. His style involves using a basic lighting setup, being reasonably close to the subject, and getting the maximum amount of animation out of them by talking to them. "I find this approach enables me to get a lot of drama out of the subject," says Guthrie. To date he has done the launch campaign for Sky Digital with M&C Saatchi and several commissions for Tango with hhcl+partners. Several of his portraits have been acquired by the National Portrait Gallery, London, and he has also donated a number of shark photographs to the Shark Trust for use in promotional material.

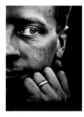

photographer	Nigel Harper
address	The New Barn
	Eythrope Rd
	Stone
	Aylesbury
	Buckinghamshire HP17 8PH
	England
telephone	+44 (0)1296 747747
fax	+44 (0)1296 747747
email	mail@nigelharper.com
website	www.nigelharper.com

Nigel Harper has been a full-time professional photographer for 18 years. Seventy percent of his business is wedding photography. He works hard to bring a fresh style to his work, employing ideas gleaned from movies and television. He gained his Associateship with the MPA in 1993 and with the BIPP in 1994, and was also awarded Craftsman with Distinction by the Guild of Wedding Photographers. His approach to wedding photography embraces photojournalism, reportage, and a touch of classical style. It is a mix that has produced a successful and individual style. When the opportunity arises, he likes to create dramatic photographs, with impact, utilizing motion blur or special lighting effects. He has lectured around the UK and abroad for many years and continues to impart his knowledge and demonstrate his style to fellow photographers. He uses Bronica 645 cameras with lenses from 30mm fisheye to 150mm telephoto, while Canon EOS cameras are used primarily for black and white. Harper now increasingly uses the Fuji S1 Pro Digital camera for wedding photography and all his portraiture.

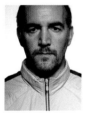

photographer	Jason Keith
website	www.jasonkeithphoto.com

From West Cornwall and via Edinburgh, Jason Keith now lives and works in Barcelona. He specializes in fashion and portrait photography for editorial, advertising, and design.

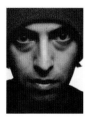

photographer	Hiroshi Kutomi
address	Flat D
	141 Hertford Road
	London N1 4LR
	England
telephone	+44 (0)20 7249 0062
fax	+44 (0)20 7249 0062
email	hiroshi.kutomi@virgin.net

Born in Tokyo in 1970, Hiroshi Kutomi moved to London in 1996. After assisting Nick Knight full-time for two years he became a freelance fashion photographer in 1999, working for magazines including *i-D*, *Vogue* (UK and Japan), and *Glamour*.

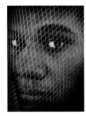

photographer William Long
address Longshots Photography
 PO Box 2333
 Fortitude Valley BC
 Brisbane
 Queensland 4006
 Australia
telephone +61 7 3893 4007
fax +61 418 980 021
email info@longshots.com.au
website www.longshots.com.au

Originally from the UK, William Long emigrated to Brisbane, Australia, and since then has built up an ever-increasing list of local, national, and international clients in the commercial, fashion, industrial, and advertising industries. His work has been widely published in everything from advertising and marketing material to leading newspapers and magazines. He has won numerous awards, including Portrait Photographer of the Year 2000 from the British Institute of Professional Photography. "Creative, almost choreographed images, give me the opportunity to express profound emotions," he says, "and to make an impact on the viewer's mind. The use of light and drama from the theatrical perspective, intentionally or subconsciously, influences all of my work. My intention is to make a difference, to make an impact, to produce a response."

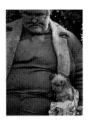

photographer Jo McGuire
address 6 Francis Avenue
 Feltham
 Middlesex TW13 4EB
 England
telephone +44 (0)20 8893 2516
email jo@jomcguirephoto.com
website www.jomcguirephoto.com

Jo McGuire is an award-winning freelance photographer specializing in documentary portraiture using natural lighting and a candid approach. Her work has appeared in a range of publications, including the *Sunday Times*, and she is available for commissions. One of her most accomplished projects to date—a photographic study of British Gypsies—has been widely acclaimed, and she is working toward producing a book on the subject.

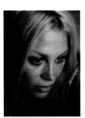

photographer Matt Moss
address The Mill House
 35 Mill Road
 Marlow
 Buckinghamshire SL7 1QB
 England
telephone +44 (0)1628 486711
email matt@mattmoss.co.uk
website www.matt-moss.com

photographer Pauline Neild
address 20 Dennison Road
 Cheadle Hulme
 Cheshire SK6 6LW
 England
telephone +44 (0)7710 095273
email paulineneild@dsl.pipex.com
website www.paulineneild.co.uk

Pauline Neild's career in photography started 15 years ago. Initially she worked for a local paper creating images in black and white. She moved on to shooting in color while working for the *Manchester Evening News*. Neild also began to work for the *Times Educational Supplement* and for Camera Press, an international press agency based in London. She won awards in the British Pictures Editors Awards two years running; the first award for black and white work, the second for feature work. "As well as press work I take on both short- and long-term commissions for the North West Arts Board, local councils, PR companies, schools, and colleges, museums and art galleries, theaters and local businesses. I enjoy finding unusual and striking images in ordinary situations."

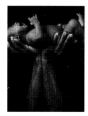

photographer	Erwin Olaf
address	Ijseltraat 26–28
	1078 CJ Amsterdam
	The Netherlands
telephone	+31 20 692 3438
fax	+31 20 694 1291
email	info@erwinolaf.com
website	www.erwinolaf.com

Erwin Olaf is a leading Dutch photographer who started his working life in photojournalism but now shoots mainly fashion internationally. His images are hallmarked by visual humor and persistent allusions to the formal expressions of art. Clients include Heineken, Silk Cut, Hennessy, and Diesel. Recently he has had numerous exhibitions in Europe and other countries worldwide.

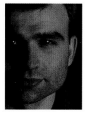

photographer	Karen Parker
address	87 Wolverton Road
	Stony Stratford
	Milton Keynes MK11 1EH
	England
telephone	+44 (0)1908 566366
mobile	+44 (0)7941 351417
email	karen@karenparker.co.uk
website	www.karenparker.co.uk

Karen Parker, UK Digital Photographer of the Year 2000/2001, provides a service that is unique in the UK. She has won many portrait awards, including a prestigious Kodak Gold Award, and these signify the creativity she strives for in both her commercial and personal portrait work. Specializing in portraiture and working regularly from concept to shoot, including retouching, means she's regularly in demand from a diverse range of businesses. She was among the first photographers to use a digital back, allowing clients to view results within seconds and/or email them during a shoot. In a real emergency, studio shoots can even take place at any hour. This level of service means everything is in-house and very personal—or, as Karen puts it: "Maybe it's time to believe the hype."

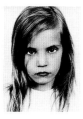

photographer	Tamara Peel
address	58 Worcester Street
	Stourbridge
	West Midlands DY8 1AS
	England
telephone	+44 (0)2380 898301

Tamara Peel, recognized as one of Europe's leading portrait photographers, has won prestigious Agfa, Fuji, and Kodak awards for her work. Having studied art and design extensively and gained an Honors Degree in Photography at Manchester, she set up her own studio in Stourbridge, England. Tamara likes to produce high-quality black and white and sepia-toned portraits, and is also an accomplished wedding photographer. In 2004 she won the prestigious British Institute of Professsional Photographers (BIPP) and Camerasure Alliance Fine Art Competition.

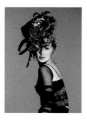

photographer	Karim Ramzi
address	5 Rue Taylor
	75010 Paris
	France
telephone	+33 140 40 4 078 77
fax	+33 140 40 78 01
email	contact@karimramzi.com
website	www.karimramzi.com

Based in Paris, France, Karim Ramzi is world-renowned for his fashion and portrait work. For over a decade, he has been photographing models and celebrities around the world, including Europe, the USA, Middle East, and South East Asia. The royal families of Saudi Arabia, Jordan, and Morocco have been among his famous subjects. Initially self-taught, through reading books and magazines and attending seminars and exhibitions, he later studied with some of the world's leading photographers, including Yousuf Karsh in Canada. Karim Ramzi has a knack for bringing out the best in his subjects, whether they are famous fashion models, kings, or ordinary people. He tries to capture the true essence of the people with whom he works, so the images look real, not posed and artificial.

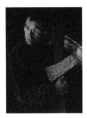

photographer	Llewellyn Robins
address	The Camera House
	34 High Street
	Hungerford
	Berkshire RG17 0NF
	England
telephone	+44 (0)1488 680790
fax	+44 (0)1871 433 2990
email	llewellyn@lrphotography.co.uk
website	www.lrphotography.co.uk

Llewellyn Robins, FBIPP, FRPS, QEP runs a portrait and wedding photography studio in Hungerford, England. He has a fellowship from the British Institute of Professional Photography and the Royal Photographic Society. He has also been awarded the honor of Qualified European Photographer. Though best known for his Romantic style of portraiture, his work has more recently shown a harder edge, most noticeably with his corporate portraiture of artists in black and white. He is currently Chairman of the Portrait and Wedding sector of the Professional Photographers Qualifying Board of the UK. His many styles of portraiture have won him numerous awards all over the world, and he is often asked to lecture on his distinctive style both in the UK and the USA.

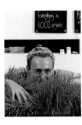

photographer	Dennis Schoenberg
website	www.dennisschoenberg.com

German-born Dennis Schoenberg moved to London in 1995 to study Film and Audio-Visual Production. Subsequently Dennis completed an MA in Photography at Westminster University in 2000. Dennis then went on to work as a photographic assistant for Rankin at *Dazed & Confused*, before moving to New York to assist Steven Klein. On returning to London, Dennis became Studio Manager for Turner Prize winner Wolfgang Tillmans. Throughout this time Dennis built up a relationship with *i-D* magazine for which he started working as a freelance photographer after having left his position at Wolfgang Tillmans. Since then Dennis has been working as a portrait and fashion photographer collaborating with various art directors and stylists for editorials and advertisements.

photographer	Tobias Titz
address	8 Little Queensberry Street
	Carlton
	Victoria
telephone	+61 3 93 49 22 29
fax	+61 3 93 47 11 82
email	office@tobiastitz.de
website	www.tobiastitz.de

Born in 1973, Tobias Titz is a freelance photographer whose work has appeared in publications such as *Spiegel*, *Groove*, and *Seven* magazine. In 2000 he was a winner in the first International Polaroid Awards. "My idea behind the Polaroid series was to get away from the usual separation between the people being photographed and the final photo print. I wanted to give people the chance of being creatively involved in the photographing process. Directly after the photo has been taken the people are given the negatives and are free to scratch into it their statement. This enables them to be, in a sense, active co-creators in the project." This series of photographs is an ongoing project.

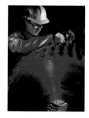

photographer	Neil Warner
address	Warner Corporate Photographer
	Warner Digital, Menlo Hill,
	Galway, Ireland
telephone	+353 91 751815
mobile	+353 (0)87 2596304
email	neil@warnerphoto.org
website	www.warnerphoto.org

Warner Corporate Photography is a specialist company servicing business in Ireland. Founded as a marketing support company, it produces photography specifically for the business sector. Neil Warner AIPPACr ABIPP AMMII is the Principal of the company and Managing Director of Irish National Corporate Photography and Digital Imaging—the parent of Warner Corporate Photography and its sister company Warner Digital Imaging and the utility site www.irishonlinephotofile.com. The photography of Warner Corporate Photography is principally used in annual reports, corporate brochures, sales brochures, exhibition stands, audio-visual presentations, and website development, through a network of associated companies in corporate graphics, web design, and corporate video. Together with its service partners, Warner Corporate Photography can provide a customized solution to meet its clients' needs. Thus Warner Corporate Photography is a one-stop shop with all the advantages of providing a diverse range of services without the attendant overheads of bigger companies.

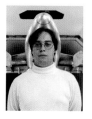

photographer	Paul Wenham-Clarke
address	Paul Wenham-Clarke Photography
	Chance Street Studios
	1A Chance Street
	London
	E1 6JT
mobile	+44 (0)7721 902670
email	paul@wenhamclarke.com
website	www.wenhamclarke.com

Paul has been a photographer for 16 years. He is based in London but travels all over the UK and abroad, shooting corporate and advertising photography. Producing annual reports, brochures, calendars, working on location, and in the studio, Paul works digitally and conventionally according to the assignment. He also completes his own image manipulation. Paul is passionate about photography and is always shooting personal work and regularly enters major photographic awards, winning Professional Photographer of the Year in 2006. Among his many clients are Hitachi, 3M, Mercury Communications, British Telecommunications, Racal, Hoover, British Aerospace, Quantel Systems, Mitsubishi, Thorn EMI, and Heidelberg.

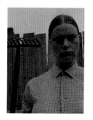

photographer	Marianne Wie
mobile	+44 (0)7799 402 595
email	contact@mariannewiephoto.co.uk
website	www.mariannewiephoto.co.uk

"I am inspired by many 19th-century photographers and painters. My work is about time and representation of time. I enjoy 'ageing' my work by finding appropriate props and location and experimenting in the darkroom." Marianne came to London from Norway in 1992 and studied sculpture at Chelsea College for four years. In her last year her work became more photography-based. She went on to study the technical aspects of photography and now works as a full-time photographer.

photographer	Dave Willis
telephone	+44 (0)1628 819008
mobile	+44 (0)7831 821155
email	dave@davewillis.co.uk
website	www.davewillis.co.uk

"I originally started shooting live gigs for *Melody Maker* music magazine and the rock magazine *Kerrang!* After a few hundred gigs, a broken nose, and the onset of imminent deafness, I thought I might have a go at studio and location music photography, as it was safer and probably a lot less painful!" Now Willis spends most of his time shooting pop bands, movie directors, and actors, although he says, "I still do the odd dodgy rock band just to keep my hand in!" More recently he has successfully turned to fashion photography.

acknowledgments

Thanks must go, first and foremost, to all of the photographers whose work is featured in this book, and their generosity of spirit in being willing to share the knowledge and experience with other photographers. Thanks also to those companies that were kind enough to make available photographs of their products to illustrate some of the technical sections.
Finally, enormous thanks must go to the talented team at RotoVision, including Commissioning Editor Kate Noël-Paton and Assistant Editor Erica Ffrench; and to Ed Templeton and Hamish Makgill from Red Design for their stylish layout.